Kristeva Reframed

Contemporary Thinkers Reframed Series

Deleuze Reframed ISBN: 978 1 84511 547 0
Damian Sutton & David Martin-Jones

Derrida Reframed ISBN: 978 1 84511 546 3
K. Malcolm Richards

Lacan Reframed ISBN: 978 1 84511 548 7
Steven Z. Levine

Baudrillard Reframed ISBN: 978 1 84511 678 1
Kim Toffoletti

Heidegger Reframed ISBN: 978 1 84511 679 8
Barbara Bolt

Kristeva Reframed ISBN: 978 1 84511 660 6
Estelle Barrett

Lyotard Reframed ISBN: 978 1 84511 680 4
Graham Jones

Kristeva Reframed

Interpreting Key Thinkers for the Arts

L **Estelle Barrett**

I.B. TAURIS
LONDON · NEW YORK

Published in 2011 by I.B.Tauris & Co. Ltd
6 Salem Road, London W2 4BU
175 Fifth Avenue, New York NY 10010
www.ibtauris.com

Distributed in the United States and Canada Exclusively by
Palgrave Macmillan 175 Fifth Avenue, New York NY 10010

ISBN: 978 1 84511 660 6

A full CIP record for this book is available from the British Library
A full CIP record for this book is available from the Library
of Congress
Library of Congress catalog card: available

Typeset in Egyptienne F by Dexter Haven Associates Ltd, London
Page design by Chris Bromley
Printed and bound in Great Britain by CPI Antony Rowe, Chippenham

Contents

Acknowledgements

I would like to thank Susan Lawson for inviting me to contribute to the series of books on contemporary thinkers aimed specifically at visual artists and arts students, and for her enthusiasm and encouragement. My gratitude also goes to Philippa Brewster for her patience, support and advice. It has been a pleasure to engage with the practices of the artists whose images appear in this book. I would like to thank Linda Banazis, Wendy Beatty, Alison Rowley and Van Sowerine for their generosity in making the images available, and giving me permission to reproduce them here. Barbara Bolt has been unflagging in her support throughout the production, and I thank her for reading and discussing the manuscript with me. Her sunny disposition, combined with a keen intellectual eye is very much appreciated. Thanks also to my family for their encouragement and for giving me the space and time to complete this work.

List of illustrations

Introduction

In a world immersed in readymade images, consumer advertising and the bureaucratised language of institutions, Kristeva's work explains how art or aesthetic experience is one of the few means by which we can generate and access images that are linked to our vital and lived experiences and that have the capacity to engender personal, political and social renewal. For Kristeva art or aesthetic experience is a *practice* that constitutes both a subject (a sense of self), as well as an object that has the power to transform meaning and consciousness. She views the production of a work of art as continuous with the production of the life of the individual, as a dynamic and performative process that moves between and across embodied experience, biological processes and social and institutional discourses.

This book will examine some of the major ideas in Kristeva's work to demonstrate how her view of language and aesthetic experience has specific relevance for elucidating visual practices, including painting, photography and film. Kristeva's emphasis on *practice* and *process* demonstrates how art itself provides us with the means for discovering and naming the knowledge it produces. In order to grasp this, we need to engage closely with key concepts in her work and then examine how they can be put to use by art makers, art viewers and others who are interested in studying the creative process and the relationship between the artist and artwork, the art object and audiences of art.

In Kristevan thought, creative production is not an application of theory, but allows practice to enter into a dialogue with theory

and to question theory. Her work challenges conventional binaries set up between theory and practice by demonstrating how theory can be a creative practice in its own right and is an inseparable aspect of practice. Schooled in the fields of linguistics, anthropology, Marxism and Freudian and Lacanian psychoanalysis, Kristeva also took up clinical practice in psychoanalysis alongside her work as an academic at the University of Paris VII. In her later work, there is a shift from an application of psychoanalytical theory as a means of illuminating the artistic process to one in which psychoanalysis as *practice* is presented as a transformative process that has parallels with aesthetic experience. Drawing on her clinical experience of the psychoanalytical process, Kristeva reveals that both art and the 'talking cure' involves what she calls 'amatory discourse', a discourse that connects embodied experience, affects and emotions in ways that expand the capacity of language to articulate meanings that lie beneath established codes and the customary use of language. Her psychoanalytical insights point to the necessity of linking artistic production and the knowledge it uncovers with social and institutional discourses through new modes of interpretation. Her conceptualisation of practice and interpretive method 'semanalysis', provide the artist and critic with conceptual tools for articulating the 'new' and the revolutionary in art.

So where should we begin with a reframing of Kristeva in ways that will open up her work for arts students, audiences and others who may be bewildered by the sheer volume and complexity of her output? If selection becomes the first necessity, on what basis might such a selection be made? From many years of teaching and working with artists, it has become evident to me that concepts and ideas, like tools, are only worth acquiring if they have some use-value. This notion underpins much of the content and the trajectory taken in this book. It has also prompted a number of questions that provide a map for embarking on the journey: what aspects of Kristeva's work are most relevant to artists? How does

her work illuminate practice and the creative process? In what ways can Kristeva's ideas be applied in interpreting artworks? How does her work illuminate the relationships that exist between artist and art object, between artists, artworks and audiences, and between art and knowledge? Finally, what might addressing these questions reveal about the role and function of art in contemporary society?

Accompanying my concern for relevance has been the imperative to present core themes of Kristeva's oeuvre that elaborate the distinction between Kristevan aesthetics and traditional conceptions of aesthetics that continue to influence the practice, teaching and interpretation of art. Central to this distinction is Kristeva's account of the dual nature of language, the relationship between body and mind, reason and emotion, and between biological and social processes. The language of art is the residue of our lived and sensory encounters with objects and ideas, and as such it has specific and embodied value as opposed to value that conforms to academic principles and predetermined standards of taste. These themes, to which I will now turn, inform the broader approach taken in my reframing of Kristeva in this book.

Drawing mainly on ideas from *Revolution in Poetic Language* (1984), Chapter 1 will examine Kristeva's account of the materiality of language and her analysis of literary practice to explain two mutual but irreducible features of language, the semiotic and the symbolic. Her theorisation of the double articulation of language emphasises how subjectivity or a sense of self is perpetually renewed through an embodied engagement with language, an engagement that involves both conscious and unconscious processes. In creative practice, this heterogeneous process articulates the logic of practice that leads to the transgression of established codes and a rupturing of meaning to produce revolutionary discourse. Kristeva's account of the subjective and heterogeneous processes at work in textual practice will

be applied to a consideration of its equivalent articulation in visual language in the work of Vincent van Gogh and Pablo Picasso, who, among others, contributed to the Modernist revolution in painting.

Chapter 2 examines the relationship between practice, experience and interpretation. It will focus on Kristeva's critique of structuralism and linguistics-based, or traditional, semiotics. She contends that such approaches limit interpretation to meanings that fall within the rules of the system, rather than those aspects that are concerned with lived experience, play, pleasure and desire. In doing so, such methods fail to seek out or articulate 'mutant' or revolutionary elements in practice. Kristeva points out that there is a need for a mode of analysis that looks for meanings that fall beyond or exceed the rules of a semiotic system. I will apply her interpretive method, semanalysis, to map these supplementary meanings, and transgressive elements that produce them, in the work of two feminist artists, Alison Rowley and Linda Banazis.

The third chapter will turn to affect, a core theme in her work and one that is central to her understanding of the creative process and aesthetic experience. Kristeva theorises affect as a structuring of psychic space that through creative practice attributes value and valency to experience and is transferred to the audience via artworks. Creative practice involves a grafting of affect to the symbolic so that language can take on renewed meaning. In Western societies where there is a growing sense of meaninglessness and a greater incidence of depression, Kristeva suggests that art remains one of the few means of restoring psychic space, a relation to self, and connection with others. In the two later works of her 1980s trilogy, *Tales of Love* (1987) and *Black Sun* (1989), melancholia and love emerge as two sides of psychic functioning that constitute the subject's relation to language, to self and to the social other. In this chapter, I will illustrate this relationship and its significance for understanding

aesthetic experience by applying Kristeva's thinking on melancholia and love to a reading of the work of animation artist Van Sowerine.

In *Powers of Horror* (1982) Kristeva examines the complex notion of abjection variously described as: a physiological functioning that maintains the boundaries between mother and child before birth; a primary process that is fundamental to the emergence of language and the development of the ego; a revulsion that serves to maintain the borders between the subject and that which threatens life; primal fear. Religious rites and rituals serve the function of mediating abjection; this mediation is also motivated by the need to maintain the separation between the sexes, prohibition of incest and by extension the general system of prohibitions around which societies are organised. Because the first object to be abjected is the mother, abjection is ambiguous in that it exerts forces of attraction and repulsion that prevail throughout a person's life. This perhaps explains why children are fascinated by frightening stories and why some of us enjoy horror films and gruesome images. Chapter 4 traces the trajectory of Kristeva's thought on abjection to her account of the relationship between abjection and transgression in art. In her recounting of this relationship, Kristeva focuses on the creative process and the site of *production*. Following my commentary on her theorisation of abjection, I will consider shifting the focus on abjection from the site of the production of art to the site of *reception*, opening up possibilities for a different kind of critique related to audience response. In particular, I will examine the way in which abjection gives rise to negative affect – fear, loathing and disgust – and how this is played out in the viewing experience. Bill Henson's 1994–5 Venice Biennale series will be the focus of this analysis and discussion.

In the final chapter I will return to the theme of revolution and revolt to examine how Kristeva's ideas might provide artists with a framework for articulating creative arts research as the

production of knowledge. This will involve revisiting aspects of Kristeva's thinking on experience-in-practice in the light of her more recent reflections on revolutionary practice in *The Sense and Non-sense of Revolt* (2000). If, as Kristeva argues, art has become one of the few means through which revolt and renewal can occur in contemporary society, it seems appropriate to turn to her work to articulate a rationale and argument for claiming a place for practice as research within the broader research arena. Kristeva's work constitutes both an implicit and explicit critique of science, allowing us to conceive of artistic research as an alternative and performative production of new knowledge. My discussion of the research project completed by Australian photographer Wendy Beatty in 2004 is a reflection on how Kristeva's work can be applied to advance this view.

The definitions in the glossary at the end of this book carry inflections or examples that are closely related to the ideas discussed within and across various chapters. I trust that this will facilitate a smooth passage through this reframing of aspects of Kristeva's thought.

Chapter 1

Language as material process

Kristeva's explanation of the relationship between language and the body is fundamental to understanding language as a material process and art as revolutionary practice. As will be demonstrated, her ideas, initially drawn from the analysis of literary practice, can be extended to visual language. Though ultimately irreducible to each other, these means of communication operate at least in part through socially agreed codes. This chapter will focus on Kristeva's theory of language and her account of art as revolutionary practice that involves transgressing rules and codes of language and the prohibitions they articulate.

Language cannot be set apart from the speaking subject and/or the subject who hears or receives language. In other words, language can only have meaning insofar as it articulates with living beings, and hence with the material and biological processes that support the lives of such beings. It becomes clear, then, that there is something prior to language that attributes value and human valency to meaning and knowledge. In Western society, a world that is saturated with visual and verbal communication, Kristeva observes that there is a growing sense of meaninglessness, incidence of depression and absence of affirmation of social bonds. She views this crisis of subjectivity as an outcome of the way in which bureaucratic organisation depersonalises our everyday practices and interactions and how institutional discourses are increasingly removed from our lived experiences. In such a world, according to Kristeva, psychoanalysis and art are

among the few means by which the symbolic world may be reconnected with the living body, our vital biological and psychic processes. Psychoanalytical theory provides the means for unravelling the complex relationship between body and mind and individual and society as a dynamic process of how we come to make meaning. Kristeva shows that as *practice*, psychoanalysis has some fundamental parallels with artistic practices. Both involve processes of revolution and renewal. The work of psychoanalysis and art is concerned with challenging institutional and other discourses that have become divorced from our vital feelings and therefore undermine our capacities for self-relation, relations with others and possibilities or motivations for agency. Initially, Kristeva looks to literature – creative textual practice – to explain how such practice involves reconnecting the symbolic and the semiotic dimensions of language. These key terms refer to what Kristeva has theorised as the heterogeneous dimension of language – that is to say, language as it signifies (the communicative function of language) and language as it is related to material or biological processes that are closely implicated in affect and emotion. In this chapter, I will explore how these and related concepts allow us to understand the revolution in Modernist art.

Central to Kristeva's thought is the notion of the subject or self as a living and constantly evolving process. How does a feeling and thinking subject come to be? What underpins this most creative of all processes and how is this related to art or aesthetic experience? Something occurs or lies behind language and meaning that must be acknowledged if we are to arrive at an explanation. In her work, *Revolution in Poetic Language* (1984) Kristeva turns to the infant's relationship with its mother prior to birth, and to its experience before language, in order show that the subject and language *emerge* from material processes; that material process is continuous with the life of the subject and has a dialogic relationship with language even after the child has

separated from the mother and has developed the capacity for speech: the capacity to be a speaking subject.

The semiotic and the symbolic

The mother's body is not a static container, but one that is experienced primarily as sound – voice rhythm, and prosody. This space or site of interactions and exchanges gives rise to what Kristeva calls the semiotic 'chora', which registers the first imprints of experience and is a rudimentary signal of language that is to follow. The chora is an articulation of bodily drives, energy charges and psychical marks which constitute a non-expressive totality, one that does not give way to form, but is known through its *effects*. The chora can be related to the dynamism of the body constantly in motion and perpetually seeking to maximise the capacities of the living organism. It is a complex of pulsations – intensities, tensions and release of tensions that occur through interactions with what lies beyond or outside the living system. Operations of the chora that precede the acquisition of language organise pre-verbal space according to logical categories that precede and transcend language. These operations or semiotic functions which are constituted through biological drives and energy discharges, initially oriented around the mother's body, persist as an asymbolic modality that governs the connections between the body and the 'other' throughout the life of the subject. They articulate a continuum between the body and external objects and between the body and language (Kristeva 1984: 27). Since the body is necessarily implicated in our encounter with language, we may now understand the 'semiotic' as an alternative 'code' of language, a 'bodily knowing' that nonetheless implicates itself in relays of meaning that are manifested in social relations.

We can appreciate the effects of this non-discursive or pre-linguistic dimension by first considering interactions between the newly born infant and the mother. A mother's smile or withdrawal of attention can be felt or apprehended by the infant without

being able to be placed in linguistic categories or related to anything else. The baby's response of crying or laughter sets up a series of interactions and effects both within the baby's body and the child's physical and social environment. New meanings and behaviours (practices) emerge through a combination of non-verbal events – the child's physical responses *and* parental responses of nurturing which involve both linguistically or socially mediated behaviour (accepted mothering practices) and non-verbal and less mediated responses that might vary according to the pitch and intensity of the child's crying. Let us take this explanation a step further and relate it to a child who has some command of language. Where the mother chooses to sing a lullaby to the child, the words of the song communicate shared social meaning: 'Go to sleep little child' constitutes the symbolic; the rhythm, tones and other auditory elements of the mother's actual singing of the song, on the other hand, articulate the semiotic dimension. Now, imagine the mother reading the words of the song in a monotone instead of singing it with all the soothing modulations that would accompany her performance. This would be less likely to have any effect on the child. Alternatively, delivering the words as a loud and angry command would certainly have an effect. In this scenario the non-verbal dimension of the interaction – loudness and frequency of crying, tone and timbre of mother's voice, for example – would articulate what Kristeva would term the 'semiotic'. In the language of art, the semiotic emerges in more varied and complex forms as the result of the artist's manipulation of rhetorical codes.

The semiotic is made up of articulatory or phonetic effects that shift the language system back towards the drive-governed basis of sound production. The choice and sequencing of words, repetition, particular combinations and sounds that operate independently of the communicative function of language also constitute the semiotic function, a function which has the capacity to multiply the possible meanings of an utterance or text. In

visual language, the semiotic is made up of articulatory effects that shift the system back to the drive-governed basis of *visual* production. This functioning is related, for example, to sensations and affects evoked by colour, visual marks and formal elements that operate independently of figuration or iconicity.

What is predominantly at work here is the way in which drive or bodily impulses implicated in the performance of verbal and visual language result in variations and multiplicity of meanings that may be produced. The drives or impulses articulated by the semiotic always operate through and in language. In creative practice, elements of the genotext or semiotic disposition of language indicates a shift in the speaking subject and a capacity for play and pleasure that refuses total constraint by the symbolic law. The semiotic disposition establishes a relational functioning between the signifying code (the phenotext) and the fragmented or drive-ridden body of the speaking (and hearing/seeing) subject. This relational functioning supposes a notion of a 'frontier' and the transgression of a frontier. Practice can thus be understood as the acceptance of a symbolic law together with the transgression of that law for the purpose of renovating it (Kristeva 1986a: 29). Leon S. Roudiez suggests that the relationship between the semiotic and the symbolic can be understood in terms of the texture of a piece of cloth interwoven from two different threads. Those that are spun by bodily drives and sensation relate to the semiotic disposition of language or what is also known as the 'genotext'. Certain combinations of letters, particular sounds (think of alliteration and onomatopoeia in poetry) are also indicative of the genotext irrespective of the meanings of the words. Those elements of language that emerge from societal cultural constraints and grammatical and other rules articulate the symbolic disposition or what is referred to as the 'phenotext' (Roudiez 1984: 5). What makes language different to the static woven cloth is that language is fluid and constantly shifting as a result of individual, social and historical usage.

Two important points related to Kristeva's work should be taken from this. The first is that for language to have any meaning or effect on us at all, it has to be spoken and/or 'heard' – it has to be put into *process*. Secondly, this putting-into-process of language must connect with our biological processes, affects and feelings in a vital way in order for language to take on particular meanings or to *affect* us. When the semiotic and the symbolic are insufficiently connected, language, communication, and hence social bonds, lose meaning and value. From this we can begin to understand how the *subject* and *practice* are crucial to Kristeva's account of language as material process. Creative practice or 'performance' of language maintains the link between the semiotic and the symbolic, between language and our lived and situated experiences.

If the semiotic and the symbolic are two dimensions of language and subjectivity that need to be connected to make self-relation and relation with objects in the world and social others possible, does this imply any possibility of the two becoming disconnected? This is not possible in an absolute sense, since the notion of the materiality of language presupposes a living (material-biological) subject of language. Kristeva's thinking, however, allows us to posit the idea of a *tendential* severance between the two. In contemporary life much of the language we encounter, the techno-speak and bureaucratised language of institutions has increasingly become abstracted from the particularities of lived experiences, drained of emotional valency. Kristeva contends that there is a tendency towards a further separation of the semiotic and the symbolic in conditions where modern institutions and discourse fail to provide everyday social and symbolic sites for practices that maintain an adequate connection of the semiotic and symbolic (Beardsworth 2004: 14).

The hypothetical positing of the isolation of the semiotic is necessary in order to explain material processes that are prior to language. It allows Kristeva to elaborate how the semiotic chora persists as motility or negativity that has the capacity to

threaten the symbolic and subvert established rules and meanings. Although the semiotic chora is pre-linguistic, its effects can only be found at the symbolic level as a heterogeneous contradiction of the symbolic. Its workings are an indication of the instability of subjectivity and the way in which the body as material process operates through and in language as a subversive and revolutionary force.

What does this have to do with art? In *Revolution in Poetic Language*, Kristeva draws on the work of a number of French symbolist poets, including Mallarme and Beaudelaire, in order to demonstrate why and how the semiotic dimension of language operates as the basis for the critique and renewal of discourse. Kristeva's account of this in relation to poetry and literature can be extended to the visual arts as will be seen in a consideration of Modernist painting. But before we proceed to this, it is necessary to understand, in more specific detail, the material processes that underpin creative textual practice.

Negativity, rejection and *signifiance*

Kristeva's analysis of particular types of literature reveals a signifying process that results from a crisis of social structures and capitalist discourses, and what she refers to as their ideological, coercive and necrophilic manifestations (Kristeva 1984: 15). Art as practice involves a confrontation between and across unconscious subjective forces and social relations, a kind of productive violence that shatters established discourse and in doing so changes the status of the subject, its relation to the body, to others and to objects (Kristeva 1982: 15). Art is different to psychoanalytic practice because the addressor and addressee are not just part of a familial or social structure, but of language itself. Kristeva contends, however, that a psychoanalytic understanding of the drives provides a means of explaining the negativity that is repressed by bourgeois society and its discourses.

'Negativity' can be understood as the processes of semiotic motility and charges, or 'death-drive', a force that impels movement towards an undifferentiated or archaic phase that precedes the subject's entry into language. Kristeva draws on Sigmund Freud to explain negativity as a drive or urge, inherent in organic life, to return to earlier states that the living entity has had to abandon under pressure from eternal forces (Kristeva 1984: 160). This relates to Freud's account of the subject's entry into language, which produces the split subject made up of the unconscious – related to the id – that is governed by bodily drives, and the ego, which follows the reality principle in order to allow the subject to operate as a social being. In the human realm, institutional discourses and their disciplinary regimes may be counted among those external or repressive forces that impel negativity. Negativity underpins the material dimension of our encounter with language in creative practice. It operates dynamically and dialectically between the biological and social order, replacing the fixed categories and oppositions of language to produce what Kristeva refers to as an 'infinitesimal differentiation within the phenotext' (Kristeva 1984: 126). Kristeva uses the term *'signifiance'* to distinguish this signifying process from signification, the conventional way in which words signify meaning. *Signifiance* is an alternative signifying process that is the result of the heterogeneous workings of language which articulates both symbolic and semiotic dispositions. This double articulation of language allows a text or artwork to signify what the communicative or representational function of the work cannot say (Kristeva 1980: 18). We have already touched on this in relation to poetry. In terms of visual art, consider for example the pointillist use of colour in the work of Georges Seurat. The impact of colour used in this way operates as a signifying process that transcends the representational content of a scene. Seurat drew on science to investigate the nature of sight and perception. He wanted to construct a theory or grammar of seeing, and his approach was

therefore a departure from the spontaneity of the earlier Impressionists. Despite, the strong conceptual and positivistic basis of Seurat's approach to painting, his practice nevertheless reveals the heterogeneous dimension of visual language and an alternative stratum of 'reality' operating beneath representation. His images emerge from harmonies of colour and light constructed by myriad tiny dots. Robert Hughes suggests that Seurat wanted to demonstrate the deeper transactions that occur between eye and mind – between biological process and thought – that occur in the construction of visuality or ways of seeing. Seurat's work *La Grande Jatte* demonstrates these infinite divisions, infinite relationships, and the artist's struggle to 'render them visible – even at the expense of "real life"' (Hughes 1980: 118).

Negativity is closely related to, and cannot be considered apart from, the related concept 'rejection'. Kristeva uses the term 'expenditure' to explain how the operations of negativity and rejection work in unison to produce the movement of material contradictions that generate the semiotic function. If negativity is a motility or dynamism that seeks an undifferentiated state, rejection is what repeatedly interrupts this movement. Rejection moves between the two poles of drives and consciousness. Think of negativity and rejection working together as a kind of pre-linguistic pulse that sets up a constant rhythmic responsiveness to language and to other objects in the world. Rejection constitutes the shattering of unity or unified meaning. Kristeva describes it as a pre-logical and alogical function which cannot be thought of outside the unity of language, because its very function presupposes some kind of unity. It has a relation or connection to language, but only in terms of what Kristeva refers to as 'scission', or a separation that opens up an asignifying crucible where meaning is ruptured, superseded and exceeded (Kristeva 1984: 147). 'Expenditure', 'negativity' and 'rejection' are related to '*jouissance*', the erotic and psychic pleasure accompanying the movement of material contradictions that generate the semiotic functioning

of language, a functioning that constitutes the excess or supplementary meanings that line or are enfolded in the signifier of the poetic text. Simply put, the *jouissance* of negativity-rejection can be related to the different feelings that the sound and combination of words evoke in different people. We can also understand *jouissance* in terms of what Roland Barthes has referred to as 'the pleasure of the text', a pleasure that comes from a movement away from the everyday and mundane meanings of language (Barthes 1975). In visual works, this can be related to colour, line, form and various patterns that operate beyond their communicative function. In her essay 'Giotto's Joy', Kristeva's analysis of Giotto's use of blue in the frescoes that line the ceiling and walls of the Arena Chapel in Padua and those that can be found in Assisi and Florence explains how *jouissance* is related to transgression (Kristeva 1980: 231–2). In these works colour disrupts and exceeds the ideological dimensions of visual narrative and breaks with the chromatic codes operating in Christian iconography of the thirteenth and early fourteenth centuries. The decentring influence of Giotto's blue carries instinctual drive into the unity of the symbolic, pluralising meaning.

Rejection is ambiguous in that it is a precondition for the emergence of new meanings and renewed or recuperated subjectivity. We can see from this how the perpetual rhythms and workings of material and biological processes that maintain the living organism – negativity-rejection … negativity-rejection – are continuous with processes that produce the subject, language and meaning. What is important to note at this stage is that aesthetic experience in both the production and reception of the artwork inscribes negativity and rejection by bringing the symbolic function into an encounter with the semiotic. This results in an unsettling and multiplying of meaning (*significance*) which puts the subject in process-on-trial. In this state, established meanings become uncertain and a struggle is set up between the conscious and unconscious forces (Kristeva 1984: 22). The ongoing renewal

and production of the subject or subjectivity underpins the ongoing renewal and production of language and meaning.

Significance, as signifying *practice*, is heterogeneous because it indicates the operation of biological urges as both socially controlled, directed and organised and – at the same time – as able to produce an excess of meanings that challenge those contained in institutional or representational discourses. If we look at van Gogh's painting *Crows Over Cornfield*, 1890, for example, this relationship becomes apparent. The unity of the composition is constantly disrupted by the impact of colour assaulting the eye and breaking up the compositional space. The crows flying above the field dissolve into indistinguishable marks that in some places may or may not be part of the sky. If we keep looking long enough, the surface of the painting induces not meaning but pure sensation, the retinal impact of colour and line. The work becomes not so much a painting of the landscape, but an externalisation of the artist's particular and embodied engagement with it through practice. Another expressionist painting, Edvard Munch's *The Scream* (1893), is also exemplary of the double articulation of visual language. This image of a landscape at sunset is poised at the edge of representational reality. The garish colours evoke emotional and affective tension and a feeling of vertigo. The twisted and embryonic figure in the foreground of the scene is barely human. Both in form and content, the work refuses to adhere to the conventions of realistic or mimetic art. If *The Scream* constitutes any utterance at all, it comes across as a resounding 'No!' And yet the repetition of curvilinear brush strokes and the rhythm produced by these and by Munch's use of colour produce ambiguity and uncertainty of meaning. It is unclear whether the scream is issuing from the figure, from the landscape or from both. Similarly, it is impossible for the viewer to pinpoint the source of the menace and/or emotional anguish that is being evoked. By giving free reign to the semiotic disposition of visual language, the work puts the viewing subject in crisis, and this triggers affective

processes resulting in a productivity that gives rise to multiple meanings or the polyphony characteristic of Modernist art.

From the brief discussion of the works of van Gogh and Munch, we can see how the semiotic, as well as being a precondition for the symbolic, functions synchronically with the symbolic. The black marks in van Gogh's painting, swirling lines and brushstrokes in *The Scream* both indicate and *exceed* their representational and compositional functions.

Kristeva stresses that the semiotic is, itself, heterogeneous since it is subject to mediation by society through contact with the maternal body, as discussed above. The earliest sensations we have are the sound-based rhythms and vibrations of the mother's voice and bodily processes, and this mode of responding continues to influence sensory responses beyond the acquisition of language. Certain colours and combinations of colours are sometimes felt to be 'loud' or 'noisy' because our raw perceptions and sensations operate sinaesthetically rather than as disparate sensory processes. Sinaesthetic responses to stimuli, in terms of tension and release of tension, pleasure and displeasure, are set up by negativity-rejection. They are precursors of affect and feeling which emerge from the series of complex interactions between the thing encountered and the 'perceiver'. For both the maker and viewer of artworks such as those discussed above, something emerges from the arrangement of forms, tones and colours, and this 'something', rather than compositional coherence, registers feeling. Feeling or affect is not an added factor, nor is it separate from physiological processes or the symbolic, but is a mode or phase of appearance that registers the semiotic. Hence the semiotic and the symbolic are not posited as binary opposites, but as two interrelating heterogeneous realms. However, the operations of the semiotic can often be ignored, masked by the communicative imperative of language or reinterpreted into dominant meanings.

What the concept of the semiotic gives us is a way of articulating physicality (of both makers and viewers of art) as part

of the explanation of the processes involved in the production of meaning and knowledge without falling back into biological reductionism. Kristeva's semiotic indicates a realm of meaning that is in excess of or cannot be contained by the signifier – a sensuous, bodily knowing that goes beyond the naming of objects or describing of scenes. What remains outside the signifier, or outside the symbolic is not an empty space or void but a hyper-differentiated realm of latent or possible values and meanings. This is why a text or a painting that has a strong semiotic disposition gives rise to multiple meanings and interpretation. We will look at this in more detail in Chapter 2.

Practice and experience

So far, we have been considering the semiotic's relationship to the symbolic predominantly in terms of language. It has perhaps become clear from the discussion concerning the materiality of language, that words and images strike the body in the same way as objects – that is, they exert a force that intensifies negativity and its indissociable counterpart, rejection. Kristeva suggests that we can appreciate this more clearly if we go beyond language, with reference to what psycholinguists refer to as 'concrete operations' that are involved in the child's pre-verbal and practical relations to objects – their destruction, serialisation organisation and so forth (Kristeva 1984: 123). Consider, for instance, a child playing with wooden blocks. Concrete operations, which include sensory-motor actions, involve handling the objects that produce results or 'transform' the objects. For example, the blocks can be arranged to configure vertical structures (a 'house' or a 'tree'?), horizontal meandering structures (a 'road', or 'path'?). Anyone who has watched a child at play will know that the possibilities are varied, endless and often quite unpredictable. Concrete operations such as these are internalised and prolonged to produce forms of 'knowledge' that precede language – they put down the mental templates that make

language possible. More importantly they put down templates that reflect the novelty of the unpredictable material interactions, and as such they hold the potential for transforming and extending language.

The relationship between this and the co-emergence of the subject and language can be explained through Freud's account of the 'fort-da' game – in which a child repeatedly throws the cotton reel out of the cot so that it may be retrieved by another. The throwing away of the object is primarily the result of negativity-rejection, an expenditure of energy discharges that mark the object as separate from the body. Kristeva explains: the very moment of rejection/separation 'fixes the object in place as *absent*, as a *sign*' (Kristeva 1984: 123). It sets up a relation between the subject – the heterogeneous system that has produced the sign – and an outside or social other. The cotton reel's appearance as a sign or mental image of the thing is an indication of material production of language. The 'real' is brought into mental presence not just as a cotton reel, but as a reel in relation to the *contextual* interactions of the game on any particular occasion. It would therefore be reasonable to suggest that the mental images produced will vary from child to child and from game to game. By extension, this allows us to conceive of practice as productivity and performativity. Understanding the function of concrete operations opens the way to appreciating why play and practice are crucial to creative production and why it is important to 'handle' the materials of creative practice, whether they be objects in a visual artist's studio or the words and structures of language. Handling or practice allows the artist to discover what materials/objects can do and how they might allow new mental images, or 'mutant enunciations' to emerge.

These productive processes can be related to Kristeva's notion of 'expenditure', which involves negativity-rejection and establishes the object/image as real and signifiable in and through language. We can only discern the functioning of expenditure as

a series of differences or differential articulations of the object in language, a language that in turn camouflages the operations out of which language emerges. This does not privilege the symbolic realm, or what is otherwise referred to as the law-of-the-father, but demonstrates the fragility of that realm, which is constantly exposed to the influence of material process and depends on the workings of the semiotic for its meaningful articulation. The admission of alternative bodily processes and their effects in meaning-making not only challenges the notion of language as a static mechanical and arbitrary system, but also accounts for the heterogeneous nature of subjectivity, which is actively implicated in ongoing processes of evolution and social change. The subject is no longer cast as an inert or passive product of discursive processes, but is reinvested with some degree of agency. Kristeva's thought therefore challenges the postmodernist idea that 'art and the subject are dead'.

Kristeva's account of semiotic functioning explains why the logic of practice is alternative to the logic of rational thought. The speaking subject, the one who uses and performs language – either in practices of making or viewing art – is at the heart of a process, revealing that the 'real' is not something that can be posited in advance and forever detached from instinctual and material process (Kristeva 1984: 126). Practice involves a subject who experiments with or practices the objective processes of language by submerging *in* it and emerging *from* it through the drives; the drives are in turn subjected to encounters with objects in the world that make up the subject's biographical and historical experience. It is in this sense that creative practice can be said to modify language and discourse to produce situated knowledge.

Art, experience and revolution

Why is an understanding of this important for acknowledging artistic practices as the production of the new and as the

basis for social change, for revolution? Kristeva's ideas on the relationship between practice and experience provide some answers to this question. Indeed in *Desire in Language*, Kristeva poses a similar question:

How does there emerge, through its practical experience, a negativity germane to the subject as well as to history, capable of clearing away ldeologies and even 'natural' languages in order to formulate new signifying devices? How does it condense the shattering of the subject as well as that of society into a new apportionment of relationships between the symbolic and the real, the subjective and the objective? (Kristeva 1980: 93)

For Kristeva, the answer lies in the notion of *experience-in-practice*, the creative production of language as *negativity* which she explains as the operation of inscribing the asymbolised or not-yet-symbolised real into the fabric of writing, of language in order to transform language. Central to this process is the notion of the desire of the subject for language and the impetus of the body in practice, as we have seen from the earlier discussion related to concrete operations. Revolution, then, is not a question of adopting a particular ideological position, but the investment of drive. In putting forward her view that art and psychoanalysis are amongst the few remaining sources of subjective renewal, Kristeva shifts our focus from the socio-political sphere – the public domain – to the personal and the private. This does not imply an opposition between them, but highlights the way in which she views art as a potent vehicle for realising and articulating a dissenting subjectivity within the networks of institutional discourses. The speaking subject is the split subject divided between conscious and unconscious motivations – between physiological processes and social constraints. The earlier discussion of *negativity* and Kristeva's thinking on the dual or heterogeneous dimensions through which the subject and language operate provides a basis for arguing that negative forces operating in the subject, rather than

economic and historic currents, must be acknowledged if we are to understand political forces and social change (Sjöholm 2005: 93).

Following on from this, Kristeva suggests that art can be understood as a second overturning of G.W.F. Hegel's dialectic (Hegel 1929). Hegel describes social and political struggle in terms of thesis, antithesis and synthesis. His notion of dialectics puts consciousness first. Marx's on the other hand emphasises materialism (the means of economic production) and its inherent contradictions as a basis for dialectical development. The contradiction inherent in all things results in a cleavage, a struggle between the two elements of the contradiction, resulting in the elimination of the weaker element. This is an ongoing process, because in Marx's model of dialectics, contradiction within the emergent victorious element perpetuates the dialectic process. According to Kristeva, art replaces economic materiality with aesthetics. This is so because aesthetics implies a subject, and the materiality of the subject implies biological processes. Marx does view human sensuous activity, practice and direct personal experience as the foundation of knowledge, but his focus on practice does not go beyond the 'practical idea' which emphasises the externality of objects (Kristeva 1984: 200). By turning inward to the material processes of subjectivity, Kristeva's notion of practice and dialectics goes beyond a view of contradiction that involves a replacement of one contradiction or thesis with another. Her view of dialectics is informed by catastrophe theory, which originated in the work of French mathematician René Thom. Catastrophe theory puts forward the idea that small changes and contradictions in minor parts of a non-linear system or field of forces can cause instabilities of attraction and repulsion that may lead to sudden changes in the whole system. In this model, when elements in the system lose equilibrium or are shattered, one element does not replace another, but shattered elements re-form to bring about a completely new system or object. Hence transformations that occur in subjectivity result in

transformations of language, and this in turn has the potential to transform discourse.

In artistic practice, heterogeneous contradiction (social-biological processes of the subject in process) is determined through a shattering of the unity of consciousness by a non-symbolised outside through negativity-rejection. If rejection invests or recognises itself within existing structures, stasis occurs and the status quo is maintained. Where drive-rejection refuses stasis, its intensity and violence (catastrophe in the system) brings forth a 'new object' prior to the return of consciousness. In doing so, it symbolises the objective process of transformation according to the constraints imposed by the movement of drives. That is to say, it produces a revolutionary 'discourse' (Kristeva 1984: 205). In the final chapter of this book, I will extend discussion of this aspect of Kristeva's thinking in relation to creative arts practice as research and the production of new knowledge.

Kristeva's theory of aesthetics suggests that in artistic practice, the semiotic function pulverises existing discourse to articulate new or as yet unsymbolised meanings through the work that arts *does* in our encounter with it. These meanings in turn constitute new sites of subjectivity – that is, new positions or understandings for us to occupy in relation to objects and the outside world. Practice therefore produces both the subject and language. Kristeva tells us that instinctual/material operations result in a transformation of natural and social resistances only if they enter into linguistic and communicative codes. Paradoxically, then, social discourses are put into play by the process of the subject, a subject that the abstraction of communicative social discourses tends to overlook. How then can we conceive of the political dimension of aesthetic practice? Kristeva contends that both in practice and interpretation semiotic motility takes up strictly individual experience and invests it directly in signification. This can be understood in relation to my earlier discussion of the relationship between negativity-rejection, affect and language.

This indicates a potential for transferring individual and private experience to an audience and hence to the public sphere. By providing new positions for subjectivity and interactive exchanges between work and audience the transformation of discourses is made possible. In the process of making and experiencing or interpreting the artwork, the addressee is the site of language itself – the place where subjectivity is reformulated and renewed through aesthetic experience. Kristeva observes that at the end of the nineteenth century, the gap between social practices as they were experienced and their representation in the dominant ideology were widened and deepened by capitalism. Because tensions between the socio-political system and the individuals within it could not be resolved through political revolution, rejection and negativity became symbolised in avant-garde literature and art (Kristeva 1984: 211). Through Kristeva's account of creative textual practice as material process we can better understand the Modernist revolution in visual art. Pablo Picasso's 1907 painting *Les Demoiselles d'Avignon* is an example that serves to ground and further illustrate Kristeva's ideas presented so far.

Kristeva notes that revolution in art occurs as a result of the effacement of lived experience at times when the gap between political systems/ideologies and social realities or real conditions of existence has widened. At such times, institutional discourses and the language through which they are expressed lose meaning and value. The bureaucratisation and secularisation of Western society and the dominance of bourgeois values with regard to sexuality at the turn of the last century resulted in the alienation and marginalisation of large sectors of society, creating a necessity for new ways of modelling and externalising subjective reality. Kristeva considers avant-garde practices of the time as both symptom and response to this necessity. Jean Metzinger, in his 'Note on Painting', first published in 1910, saw Cubism as the decisive modern movement, and Picasso and Braque as its leaders. Metzinger argues that Cubism was nothing less than a

fundamental revolution in the language of visual art, and his observation on Picasso's practice comes close to grasping what Kristeva's psychoanalytical account of material processes tells us about the production of the new through practice:

Picasso does not deny the object, he illuminates it with his intelligence and feeling. With visual perceptions he combines tactile perceptions. He tests, understands, organises: the picture is not to be a transposition or a diagram, in it we are to contemplate the sensible and living equivalent of an idea, the total image. (Metzinger 1992: 178)

So much has been written about Picasso's work, and in particular about *Les Demoiselles d'Avignon*, that the reader may be wondering why this painting has been chosen to illuminate Kristevan thinking. I suggest that it is precisely the revolutionary power of this work that demands repeated engagement. This lies in the intensity of its semiotic disposition, an intensity that continues to throw up a multitude of possible meanings and interpretations. Moreover, the *jouissance* of the direct and bewildering encounter with the work raises so many questions – and as Kristeva has shown, a question triggers desire – the desire to find a language that is adequate to negotiate the space that the question opens up. Picasso's painting works both at the level of critique – a critique of decorative art, idealisation of the female nude and traditional aesthetics. The work challenges bourgeois values about sexuality, and may also be viewed as the search for a language capable of externalising the private and individual experience of the artist. We cannot be certain of all of Picasso's motives and intentions. In view of Kristeva's account of unconscious and material processes of subjectivity in creative practice, it is not necessary for us to claim that certainty. Picasso himself has commented, 'A picture comes to me from miles away: who is to say from how far away I sensed it, I saw it, I painted it? And yet the next day I can't see what I have done

myself' (Picasso 1968: 273). Picasso's comment points to the difficulty of articulating the processes involved in creative production. This is because any moment of stasis that restores the thetic and allows knowing or 'understanding' involves the use of language:

The new object is the moment of the process whose conflict constitutes the most intense moment of rupture and renewal. Consciousness tends to repress this struggle within heterogeneity which takes the subject into an 'externality' he rejects only to posit it again renewed. (Kristeva 1984: 204)

It is this struggle that produces what consciousness views as the moment of the appearance of the new object. At the place of the struggle itself (of the movement of material process or the 'shock' of the new), the appearance does not exist as anything other than *jouissance*. The subject is the signifying process itself, which can be invoked in experiencing the work as a spectator. The subject can therefore only be anticipated in an always *anterior future*. At best, we can only articulate partial meanings through practices of interpretation, which inevitably trigger further processes of material production, of meaning – made possible through subsequent encounters with the artwork. This is the process that generates and extends artistic and other discourses. Lisa Florman (2003) suggests that Leo Steinberg's essay on Picasso's painting has profoundly changed the way the work has come to be understood by conveying the actual experience of a scene in a brothel. This is because it is an interpretation of the painting itself, as experienced by Steinberg, rather than something that is imposed from outside. The meanings of the painting are therefore as much to be found in the spectator as in Picasso. The spectator constructed in Steinberg's essay is not merely an implied reader looking in reflectively from outside, but the ultimate maker of meaning.

With reference to Kristeva, we can say that in the *Demoiselles*, direct embodied address is triggered by the strong semiotic

disposition and formal qualities which above all create the ambiguity and polyphony that prevents distant contemplation. The asymmetrical distortion of the figures and faces, and the rhythms of line and form, alternate the spectator's gaze between elements, figuration and chaos. The pictorial space creates a pulse that produces a visceral engagement; the monstrous and mask-like faces are alienating and strange, evoking negative affect akin to fear. Steinberg describes the effects of Picasso's composition in the following way: 'Our vision heaves in and out, a variable pressure, like the pitching of a boat in high seas or a similitude of sexual energy' (Steinberg 1988: 33).

For a work to engender revolution, Kristeva says that it must take communicable form. The force of drive-rejection in practice makes possible the rediscovery of a new object by the reconstituted subject. This rediscovery occurs 'after the fact' and locates the new object in relation to the social structure. In order to establish if revolutionary or founding discourse has been produced, the new object must undergo a testing through the process of practice-truth-practice to make it correspond to objective necessity (Kristeva 1984: 205). This occurs in the making of the work when the artist achieves a moment of stasis that is adequate to his or her vision, but also in interpretive practices. The true or 'truth' is not an absolute, nor is it the positing of a transcendental ego, but a 'path of correction' that reconstitutes the object in relation to a lived reality. This procedure is evident in Picasso's making of the painting. The realisation of *Les Demoiselles d'Avignon* indicates sustained engagement with and critique of extant discourses and practices.

The work bears methodological, ideological and philosophical traces that take us back to Ingres's 1863 painting *The Turkish Bath* – and if we are to take into account the idealisation of the female form in traditional nude painting, we may go back even further in history to Plato. Leo Steinberg's account of this work suggests that *Demoiselles* emerged not solely, but largely from a

series of extrapolations and transgressions that took the Ingres's work as one of its starting points. By drawing on sketches from Picasso's preparatory studies for the painting and other examples of Picasso's work, Steinberg demonstrates that Picasso was aware of the discursive and methodological fields through which his artistic process was operating.

How might critical commentaries on *Les Demoiselles d'Avignon* be understood in terms of Kristeva's theories of subjectivity and experience-in-practice? Let me turn first to William Rubin's (1994) account of this work. Referring to Picasso's preparatory drawings, Rubin suggest that the painting found its genesis in and was an extension of the *vanitas* genre. He uses Erwin Panofsky's iconological method to comment on the symbolic significance of the medical student holding a scull in one of Picasso's earlier studies (eliminated from the final work) – as well as other symbolic elements in both the preparatory studies and the completed work linked to psycho-biographical accounts of Picasso's life – to argue that *Demoiselles* is an allegory, or a more distanced contemplation concerning physical degeneration and death (Rubin 1994: 58). Steinberg puts forward a different reading of the work, though what I am presenting here is a simplification of his essay. His thesis contends that Picasso's painting is a refusal of traditional distanced, idealised and decorative renderings of the nude in painting, in favour of a direct confrontation with sexuality – indeed, a direct experience of the sexual encounter (Steinberg 1988). Steinberg draws on a vast body of earlier commentary and refers also to other artistic antecedents:

The *Demoiselles* has been historicised and surrounded by a vast, varied ancestry. The influences imploding on this great masterpiece have been found to include not only Iberian and African art, to say nothing of Cezanne's compositions of bathers; we learned that they included Caravaggio's *Entombment*, Goya's *Tres de Mayo*, Delacroix's *Massacre At Scio* and *Femmes d'Alger*, and Ingres' *Turkish Bath*. (Steinberg 1988: 71)

We may deduce from this observation that Picasso must have been aware of at least some of these influences, and that the making of this painting must have involved sustained critique, engagement with philosophical and other discourses and technical aspects related to painting, in particular to painting of the nude. We can further surmise that this task involved locating the work at hand in relation to those discourses and testing his own creative vision and lived experience against these. On the basis of the way in which Picasso's work has ruptured and transformed thought and practices, and continues to validate and be validated in ongoing discourses, it is considered to be revolutionary.

But what of the artist and particularities of artistic practice that are not accounted for in critical commentaries? Kristeva's notion of subjectivity is intended to give us a better understanding of how the subject or self is constituted *through* and positioned *in* discourse – and its points of insertion, functioning and dependencies on the heterogeneous symbolic system – that is to say, how a subject emerges out of discourse through material processes. Her approach also suggests the need to provide an adequate account of the relationship between the particularities of lived experience and discourse.

Towards the end of his essay, after garnering an impressive body of criticism and engaging in a close formal analysis of the work, Steinberg comments:

Let the truth be known…The other day, I learned from a well-informed New Yorker (excuse the redundancy) that the secret is out: Picasso in 1907 had contracted VD, and painted the *Demoiselles* to vent his rage against women. (Steinberg 1988: 71)

Could it be then, and without negating all the other interpretations, and the intentions and motives the painter may have had, that this work, often hailed as the birth of Cubism, emerged from the particularities and passions of lived experience, experience that

could not be expressed in anything less than a new visual language, an extension of the possibilities of discourse?

Lisa Florman draws on both Rubin and Steinberg's account of the making of the painting to observe that before Steinberg's essay the possibilities of viewing the work as a direct sexual encounter remained largely inchoate:

Before (his) essay, the *Demoiselles d'Avignon* was the birthplace of cubism, the marker of the epochal shift from content to form in modern painting. After Steinberg's essay, it has become the marker of an epochal shift to a new kind of engagement with sexuality, one whose immediacy was unprecedented in the history of painting. (Florman 2003: 769; Florman cites Green)

Florman's engagement with Rubin's and Steinberg's account of Picasso's painting is illuminating as much for its thesis, which suggests that *Demoiselles* is a study in both detachment and immediacy that emerges through self-discovery predicated on *experiencing* the work (the work that the painting *does*), but also for its relevance to the issue of the objective and subjective positioning of the artist. It is *experiencing* that allows us to 'think with the other' (Florman 2003: 777). Experiencing the painting becomes an activity in which we may be overcome by the extreme otherness of the semiotic disposition of the work, or instead return to a more symbolic modality of engagement that finds adequate expression in interpretive discourse. Florman suggests that it is the instantiation of these *two* positions through the alternating style (one more poetic and one more prosaic) of Steinberg's account that allows us to experience the painting more fully. Her commentary is in accord with Kristeva's view of interpretation as practice, and it is this aspect of Kristeva's thinking that will be the central concern of the following chapter.

Chapter 2

Interpretation as practice

In the previous chapter we explored Kristeva's thought on how avant-garde art results in the destructive and rupturing return of semiotic elements into established discourses. This is accompanied by the transformation of subjectivity, of meaning and of the subject's relation to objects in the world. The constant frustration and repression of human capacities produces negativity-rejection, forces of drive, that through experience-in-practice constitute forms of agency, and therefore the potential for political and social action. Kristeva has sometimes been criticised for failing to develop a clear account of just how artistic practices translate into social and political change. Her theorising of poetic language and art as revolution does not concern itself with particular causes or political struggles, but points to the way in which creative practice operates as a broad and radical critique of Western capitalist culture and its extant discourses – and in doing so offers new perspectives and new positions for subjectivity to occupy. Creative texts provide the *precondition* for social action by subjects or people to come. We may conceive of such subjects not only as audiences and publics of art, but as the artists themselves, who consciously seek the visual and verbal means to reveal what is not contained in established discourses, and hence to articulate possibilities for political agency and dissent. This can be seen, for example, in (and any number of other avant-garde movements and artists could have served to illustrate the point) the practices of Dada artists such as Otto Dix and George Grosz, whose satirical

paintings and sculptures were anti-bourgeois, anti-capitalist, anti-war and indeed anti all traditional values that typified Western societies of the 1920s and 1930s. Feminist and so-called post-colonial practices provide fertile and more contemporary illustration in this regard. However, Kristeva's work is not so much concerned with the political efficacy of avant-garde practices as with subjective mechanisms and processes that lead to the disruption of language, and hence to disruptions of established modes of thought. The perpetual and dialectical evolution of subjectivity as a residue of material processes is a fundamental basis for renewal and revolution. This chapter will focus on Kristeva's thinking about interpretation and analysis as practices that can illuminate such processes. It begins by posing the following questions that are pertinent to practising artists and critics: what is the relationship between practice, experience and interpretation? What distinguishes negativity-rejection (material forces of drive) from desire? How can the heterogeneous, non-discursive processes that transform meaning be articulated in communicable form and therefore be made available in critical discourses? In attempting to answer these questions, I will first consider Kristeva's ideas on practice as the critique of discourse. The second part of this chapter will apply Kristeva's analytical and interpretive method to a discussion of a number of paintings in order to map the disruptive and transformative potential of artistic production.

Through her positing of the semiotic disposition of language, Kristeva points out how the creative text can operate according to both communicative and supplementary registers. Interpretive practices are no less complex. Indeed Kristeva puts forward the view that there is no essential separation between practice and theory – between the practices of making art and practices of interpretation. The key to illuminating Kristeva's account of interpretive practices is her focus on *writing* and what she sees as the necessity for a knowledge of the literary 'machine' (Kristeva 1980: 93). In her essay 'How does one speak to literature?'

she points to the basis of such knowledge in the interpretive method/writing of Roland Barthes, elaborated in his work *Critique et Vérité* (1966). The question that Kristeva poses is an interesting one, because it not only moves us away from the notion of speaking *about* literature, but also invokes Kristeva's own theorisation of the 'speaking subject' (Kristeva 1986a) to which I will return presently. Kristeva says of Barthes's critical writing that his method looks at practice as a symptom of the ideological tearings of the symbolic and social fabric by the semiotic through creative practice. She contends that Barthes's work gestures towards a new metalanguage or interpretive practice that locates literary practice (and by extension other artistic practices) 'at the intersection of subject and history' (Kristeva 1980: 93). This method goes beyond linguistic analysis and the search for meanings solely in the rules and systems of language. It recognises that these rules are always subject to alteration because they are predicated on corporeal, biological, vital and historical elements (Kristeva 1980: 118). Practices of interpretation are doubly implicated in these elements, through their relation to the subjectivity of the artist in the making the work, and subjective processes of the reader/interpreter. For Kristeva, interpretation involves examining how the work of art operates as a productivity that *exceeds* established rules and conventions. This is necessary if we are to account for what is new or original in creative utterances, and subsequently for evaluating how such utterances become implicated in social and cultural change.

Desire and language

I have already suggested that Kristeva's account of poetic language in *Revolution in Poetic Language* can be applied to visual and other codes. Similarly, her notion of writing or literary practice corresponds to fundamental aspects of meaning-making in other artistic practices. The core of this contention lies in the centrality of subjectivity and the material processes out of which

subjectivity, and hence meanings, are produced. In order to grasp this in terms of interpretive and critical practices, we need first to deal with the issue of language and desire. Kristeva invokes Lacan's notion of desire, and then moves beyond it. A brief outline of Lacan's account of desire presented in *Écrits* (1977) will serve to illuminate the distinction between the two thinkers, a distinction that needs to be made in order to appreciate Kristeva's more radically materialist view of aesthetic experience. In Lacan's schema, desire gains its first orientation in the infant's relation to the face-image of the nurturing primordial mother, a mother that is experienced as a being without lack (the phallic mother). Desire subsequently emerges in the mirror stage, in relation to the child's image of its own body or that of the mother as ego ideal. The child's entry into language and development as an individual ego proceeds in relation to social meanings and norms that are woven through the symbolic. This is accompanied by recognition of the mother as lack; entry into language therefore implies castration of the phallic mother. Hence, in Lacan's thinking the phallic mother emerges *retroactively* in relation to language. Desire as lack thus refers to a drive that is constantly in search of the lost object ('the little object a' – the phallic mother), as well as what is repressed in relation to the whole symbolic field, the chain of signifiers that encompasses the social other. This chain of signifiers constitutes desire on two counts: firstly because the signifier is only a partial substitute of the fullness of reality as it is experienced, and secondly because the fullness of meaning is deferred in the movement from one signifier to another: 'a cat'–'a four-legged animal'–'a furry animal', and so on. Moreover, in Lacan's model of language acquisition, meaning is not conferred by the child or through the subject's own selection of signifiers, but by the child's mother or the addressee of the message, who interprets the message according to the rules and available signifieds of her own particularised language as it operates in relation to the broader symbolic field of the mother tongue.

Therefore, a gap develops between the message as it is sent and the message as it is heard. This suggests that something lies beyond language as the satisfaction of the child's needs, and also the child's limited ability to provide for the m/other's satisfaction. Lacan called this lacking or lost object related to a striving for satisfaction the imaginary phallus; its absence also relates to unconscious desire (Levine 2008: 13).

For Lacan, then, language as the articulation of the split subject marks the absence of the object since the signifier replaces the object and cannot retrieve it in its fullness (Lacan 1977). Kristeva would agree that this underpins desire *for* and *in* language – both for the maker and the reader/spectator of art (Kristeva 1980). However, Kristeva moves away from Lacan in her positing of the semiotic dimension of language. This makes something available in language other than what language and the unconscious in/of language can contain. Semiotic motility which is influenced by pre-oedipal or pre-imaginary elements produces interference (catastrophe) that unsettles and ruptures the entire conscious/unconscious system. The re-forming of elements in this process towards meaning produces something *new*, a *repetition* or return of language with *difference* – what may be termed 'mutant enunciations'. Hence, from Kristeva's account, we may view desire not as lack, but *productivity*. How can this shift in understanding of desire as an aspect of interpretation be more fully grasped, and why is it significant?

One of the tasks of interpretation involves bringing to light the new meanings produced in the work of art in relation to discourses that have either repressed or have hitherto failed to articulate them. Interpretation implies an interrogative – the asking of a question: 'What is it?' 'What does it mean?' It implies a search for an absent object of knowledge. This implies that interpretation triggers desire in a Lacanian sense. Kristeva's departure from Lacan, however, is underpinned by her view of language as heterogeneous. She argues that desire occurs as an

index of heterogeneity at more than one level – not only because it operates in relation to the absence that the signifier implies, but also to what the symbolic does not make explicit: instinctual drives and historical particularities of the subject as material process (Kristeva 1980: 116). An encounter with the artwork is also an encounter with the material heterogeneity of the language of the work. The interpreter as speaking subject is thus put into-process and on trial. It is in this sense that we can begin to understand interpretation as creative production, rather than as a circulation of signifiers.

Kristeva turns to Freud's concepts of 'thing presentation' and 'word presentation' to elaborate phases of the subjective processes that may occur in an encounter with literature/art whether as maker or reader/spectator. Freud tells us that the presentation of an object to consciousness is split into the presentation of the word and the presentation of the thing. Freud posits word presentation in relationships involving two categories: the perceptual and the verbal. Thing presentation refers to the pressure of the unconscious drive linked to or provoked by objects. Thought denotes conscious processes including various logical operations resulting from the imposition of repression (Kristeva 1980: 217). The interesting thing about word presentations is that they are also derived from sense perceptions. This is because the drive's pressure is directed at an external object or the word as it is apprehended; also at an internal object or the word's biological articulation through vocalisation, and finally at the word as a sign. In this way inside and outside are linked by two instinctual pressures that modify both the order of thought – the symbolic – as well as the thing presentation. Because interpretation involves experiencing art as both thing presentations and word presentations, we can claim that a second order of production (reflection on the work by the practitioner researcher who creates the work, or by another who interprets the work) also serves a radical and productive function.

This illumination provided by Kristeva via Freud indicates the importance of analysis in and of practice as a means of extending and renewing discourse. Kristeva goes further by advocating a specific approach or method of analysis. Leon S. Roudiez refers to Kristeva's 1970 essay 'La texte du roman' to explain her view that there is a need to focus on the text not as a product for consumption, but as a process of productivity. If one is to account for the production of a work, one needs to investigate the forces that brought it into being (Roudiez 1984: 7). These are made up by its total context – conscious, unconscious, preconscious, linguistic, cultural and literary dimensions. While this may require knowledge from various domains, both within and beyond the artistic tradition from which the artwork emerges, it is the text or artwork alone that brings such forces to bear upon meanings that emerge. The reading of a text is an initial phase of an interpretive account of the work, one in which conceptual supports are muted because of the workings of thing presentations and desire as productivity in relation to drives that are influenced by the work's semiotic disposition. In writing, this refers to the sound networks and rhythms of the language, and in visual and other forms of art to the visual, tactile and spatial configurations that engage directly with corporeal and sensory responses. In the previous chapter, reference was made to Lisa Florman's analysis of Leo Steinberg's groundbreaking commentary on Picasso's *Les Demoiselles d'Avignon*. Florman contends that it is Steinberg's recourse to poetic language that allows his commentary to communicate his particular embodied experience of this work and therefore to communicate something about the work that previous analyses had not been able to do. This would seem to transfer the source of meaning from Picasso to Steinberg. Certainly the reader brings his or her own particularities to the interpretive process. However, it is the text *itself* that engenders and configures productivity in interpretation because of the particular relation that it sets up between the speaking subject and the object(s)

encountered. We may conclude that the crisis engendered by the semiotic disposition of Picasso's painting triggered the creative and poetic production by Steinberg that enabled him to reveal and communicate something of the forces that the painting puts into play.

Kristeva draws correspondences between the psychoanalytic situation and interpretation to account for the way in which aspects of the productive process of making the work is transferred to the audience/spectator. She refers to the text or artwork as the 'analyst', and the reader as the 'analysand' (Kristeva 1984: 209). The reader need not be alarmed by this psychoanalytic analogy. Kristeva's psychoanalytic method departs from traditional psychoanalytical discourse in a number of fundamental ways, as I will discuss in later chapters; and significantly, in relation to the present discussion, she shows where the analogy falters by drawing a clear distinction between the transference device of psychoanalysis and those inter-subjective or transference relations that are a feature of creative practices and aesthetic experience. The heterogeneous language of the text or artwork becomes the site of inter-subjective exchange that is controlled more by the structure of the text/artwork than by the other, the addressee. Psychoanalytic transference aims to reintroduce the process of rejection into the moulds of interfamilial relations and therefore tends to ossify the subject in relation to this unity. In contrast, *practice* calls on rejection itself, and, as a replacement for the thetic phase (the phase of unity), offers not an identifying addressee or analysand to converse with, but rather 'processes and objective laws to discover' (Kristeva 1984: 205). Because the logic of rejection is that of contradiction and renewal, as we saw in the previous chapter, practice escapes the normative and normalising impetus of psychoanalysis by rupturing the edifice, the phallic law of the signifier, upon which it stands. In Chapter 5, I will return to this aspect of Kristeva's thought in a discussion of its application in creative practice as research. For the remainder of

this chapter, I would like to turn to an explanation and application Kristeva's analytic method, 'semanalysis', with reference to creative visual practices.

Interpretation as practice: a semiotics of experience

Kristeva's account of the 'system speaking subject' (Kristeva 1986a) is central to understanding her semiotic method, semanalysis, and the way in which it departs from earlier or linguistic-based semiotics. In the light of what has been covered so far in this book, a working knowledge of her method should not be too difficult to grasp.

The first point that Kristeva makes in arguing for the necessity of a new semiotics is that in studying social practices, semiotic analysis shows that they are specific expressions of a general social law. This law relates to a consensus of meanings that the rules of a given social-symbolic system allows. Structuralist semiotics was thus concerned with the 'systematic description of the social and/or symbolic constraint within each signifying practice' (Kristeva 1986a: 27). It therefore records the informational aspects of the signifying system – those aspects that are concerned with social exchange rather than with play, pleasure or desire. Given that the general purpose of semiotics is the study of sign systems and their codes in order to determine the meanings they allow, Kristeva raises the question of how semiotics can go beyond its own presuppositions to specify what falls outside the system – such a semiotics would then be self-reflexive about the practice of semiotics itself.

Another aspect of Kristeva's questioning of linguistic-based semiotics is related to the notion of the speaking subject. She suggests that there is an underlying tendency in earlier semiotic models to posit the act of speaking or using language and its systems of rules as the act of an ego cut off from its body, its unconscious and its history. Freudian psychoanalysis, with its theory of the unconscious and the spilt subject, suggests the need

for a semiotics that looks at both sides of the split and takes account of non-discursive and biophysiological processes as part of the signifying practice. She puts forward the term semanalysis as a semiotics that looks at meaning not as a sign system, but as a signifying process that cannot be fully contained by a system of rules because biological and unconscious processes cannot be bracketed out. Such a semiological approach would then become a process of productivity in itself. Through its reflexive analytical procedure, such a method would have the capacity to indicate points at which a signifying process exceeds the rules of the system to generate a surplus of possible meanings.

In order to demonstrate the value of Kristeva's method for an engagement with visual artworks, I propose to apply her approach together with a functional semiotic model of analysis, that of Michael O'Toole (1994), which is strongly influenced by M.A.K Halliday's systemic-functional theory of language. O'Toole's linguistics-based semiotic model starts by studying the text of the artwork, 'its structure and texture rather than the external circumstances of the time and place when it was commissioned and executed, the social, political and economic conditions that made it possible, or the state of health, wealth or mood of the artist' (O'Toole 1994: 170). O'Toole's functional semiotics involves a study of the work of art as a system of signs that fulfil particular functions: the modal function relates to how the work constructs, directs and configures the viewer's gaze; the representational function serves to portray figures, actions and scenes that constitute communicable content; the compositional function relates to the interplay of formal elements – verticals, horizontals, diagonals and rhythms of colour and light that allow the work to operate as a coherent text. The findings from such an analysis may then be considered in relation to historical and cultural contexts. Though it starts with the work itself, like other semiotic models of analysis, O'Toole's functional semiotics is therefore concerned with the meanings that the artwork produces as a signifying

system according to the laws of a broader social semiotic. His notion of the 'semiotic space' created out of the work as text – and the work's context, including that created by a particular viewer, remains circumscribed by the various extant discourses against which any particular interpretation may be made and tested. In other words, this model ultimately emphasises one side of the split, that of the external social semiotic field. The approach does not take account of heterogeneity, of the speaking subject as an open system of infinite possibility.

O'Toole presents functional semiotics as an alternative to the simple and leisurely enjoyment of painting, which produces what he describes as a somewhat 'inchoate, more dreamlike image'. The underlying assumption here is that those meanings that cannot be grasped in relation to the rules of a socially and culturally determined context, or which articulate the 'other side' of the split, are not admissible in discussions of the text *as a work of art*. Apart from restricting definitions of art to those that are predetermined by established discourses, this semiotic approach raises the question of originality, of how the 'new' emerges, and subsequently of how to pinpoint the way a text or work of art refuses to line up with any given system or set of rules. What such an approach elides is an account of an artwork's creative or revolutionary dimension. Kristeva's notion of the speaking subject and the text as signifying *process* opens the way for a mode of analysis that acknowledges the interplay between conscious and unconscious/preconscious processes of productivity. This allows analysis in, through and of practice to map points at which a work begins to subvert discourse and to articulate the 'mutant utterances'.

Semanalysis and the X function

Kristeva has shown that conscious/unconscious, body/mind pairings which have tended to be viewed as binary and oppositional may be recast as relational elements in the ongoing

constitution of subjectivities and meaning effects. Her notion of the speaking subject and its relation to the heterogeneous nature of language has been a crucial underpinning for this position. From her theorising, we see how all meaning-making practices involve an interplay between the relatively fixed or customary meanings of social formations and discourses that operate through symbolic code, and those unconscious pre-symbolic and primary processes of the bodies involved in practice. The view of this interplay as a feature of artistic practice can also be applied to practices of interpretation and analysis of artworks. Engagement with an artwork activates those mutually structuring dimensions encapsulated in Kristeva's conception of the symbolic/semiotic relationship. Her work recognises that there is a need in interpretation to distinguish between phallic and non-phallic or non-oedipal elements and to acknowledge ways in which these elements infiltrate the symbolic to produce the asignifying tendency of creative texts.

One may ask, 'Why bother with this non-discursive domain since a close scrutiny of so-called non-discursive elements shows that they can only be given meaning in discursive structures?' Such a view contains its own internal contradiction by obscuring and denying what it implies: that what counts as knowledge and meaning is structured by the repressive imposition of the rules of discourses. The task of interpretation, like that of creative textual practice, involves a questioning and exposure of such rules in order to recuperate meanings that they repress.

By recasting O'Toole's functional semiotics in relation to Kristeva's notion of the semiotic disposition, I am proposing to introduce an additional function, the X function, which traverses and interpenetrates all three functions – the modal, representational and compositional – and their subsidiary units and elements, in order to demonstrate semanalysis at work. The X function relates to pre-oedipal processes; it extends the capacity of semiotic analysis to be self-reflexive, and permits

the mapping of elements that exceed established discourses; it allows the viewer/interpreter to point out the specificity of a creative signifying practice in terms of its potential to transgress, subvert and unsettle fixed readings. The X function therefore indicates a stratum of meaning that operates beyond and alongside the formal system. Since the semiotic disposition is to a lesser or greater degree a failure of language to 'fix' meaning, this capacity is present in any interpretive system, but it is one which has tended to be underemphasised or ignored as 'noise'. Such a tendency has obscured an appreciation of productivity and its potential to release dimensions of subjectivity and meaning that the logic of the symbolic and established discourse partially, but never fully, succeeds in repressing. Kristeva's semanalysis is a self-reflexive approach to engaging with artworks that recognises the ever-provisional nature of interpretation. Donna Haraway's notion of partial perspective and embodied vision (Haraway 1991) may be invoked here, since it also implies a reinsertion of the subject as agent and actor in relation to the production of meanings and their effects. The view from 'somewhere', from the speaking subject, questions notions of a free play of signs, and it is a view that has promoted a resistance to interpretation in postmodernist discourses. It is a resistance that can be deployed against repressive mechanisms of discourse that censor particularities and the situated nature of truth and knowledge related to individual subjectivities and lived experience. Let us examine this more closely by applying Kristeva's method to examples of creative visual practice.

Interpretation as interactive labour

The notion of heterogeneity and desire, as it is outlined in Kristeva's work suggests that there is some correspondence between the experiences of viewing and making art. Both activities involve interplay between primary biological and perceptual processes and cognitive operations through which

thought or symbolically structured meaning effects are realised. The idea that an excess of meaning is derived from unconscious and somatic processes and the semiotic disposition of texts is frequently supported by the comments of artists on their own practices. I have already alluded to Picasso in relation to this. Picasso not only acknowledged the ineffable and unconscious dimension of the creative process, but also recognised that once the work has been made, the specific logic of that practice is obscured by the commodification of the work as art object:

A picture comes to me from miles away: who is to say from how far I sensed it, I saw it, I painted it? And yet the next day I can't see what I have done myself. How can anyone enter into my dreams, my instincts, and my desires, my thoughts…and above all grasp what I have been about – perhaps against my own will? (Picasso 1968: 273)

It is interesting to note the way in which Picasso's reflection on his working process moves from references to the sensory and instinctual to that of thought. Could this be a reduplication of the phases and processes of making? He continues: 'A painting which has a certain significance for the man who did it, as soon as it is bought and hung on the wall takes on quite a different kind of significance and the painting is done for' (Picasso 1968: 272).

This view of the artist's struggle to articulate subjective processes at work in practice is a further indication of the need for a metalanguage of interpretation in order to recuperate, at least partially, the logic of practice that is lost once the work is subsumed into the logic of the symbolic and of institutional discourses. In addressing what is specific to the procedures and effects of practice, an alternative mode of semiotic analysis emphasises the viewer's relationship to the work as material sign. It provides a means of entering the signifying territory of the work and generating an interactive dialogue between the work and the viewer, which to some degree also brings artist and viewer together. However, interpretation as a task that is brought to the

work by someone *other* than the artist who made it is also the point at which the work may become despecified in terms of the body and experiences that produced it. The analysis of works to follow, which includes an interaction between my commentary and the artists' own reflection, is intended to illustrate the differential operations of agency across the practices of viewer and maker. It also provides a means of demonstrating and testing how engagement with artworks involves trans-subjective experiences

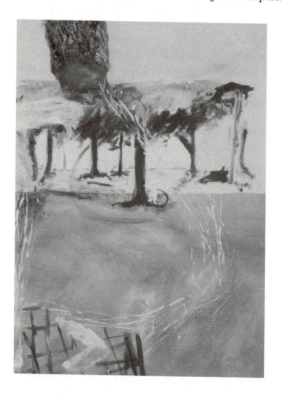

1. Alison Rowley, *Picnic Figure and Child* (1992), acryllic on canvas.

linking artist and spectator. In later chapters, I will examine how such processes produce unpredictable responses and resistant readings.

The works of two women artists to be discussed shed light on how feminist practices operate as a critique of hegemonic discourses – in particular in relation to the ways in which, in the European tradition, painting, until relatively recently, has been viewed as a predominantly male activity. Both artists to be discussed appropriate the language of painting in order to challenge its presuppositions. Since self-representations of women operate as sites of contestation where the premises of phallogocentric rationality and their implication in patriarchal values and power relations are constantly being negotiated, such works are exemplary of Kristeva's notion that in creative textual practice specificity is articulated through the workings of *significance*, which I suggest indicates the operation of the X function or semiotic disposition of the work.

The first work, Alison Rowley's *Picnic Figure and Child* (Figure 1), was painted in Western Australia and exhibited in an exhibition entitled *Feminisms* at the Perth Institute of Contemporary Art in November 1992. While the work can be associated with the pastoral/arcadian genre and an established tradition of 'picnic' paintings, it resists any fixed categorisation. Stylistically, the painting falls somewhere between Impressionism and Abstract Expressionism, but also displays Surrealistic elements. In short, the work problematises the notion of genre and, as further analysis will show, cuts across many of the conventions and techniques that might customarily be expected of landscape painting. A close reading of the work via semanalysis reveals moments at which the artist's negotiation of the substances and surfaces of a painting realises specific and multiple effects through an interplay between symbolic structures and heterogeneous disruption of those structures.

Although interpretation can be initiated through any of the functions that have been described in O'Toole's semiotic model, in looking at Rowley's work I will start with the representational function, since this provides the viewer with a set of provisional meanings that can subsequently be tested against the systems and elements of the modal and compositional functions. These, you will recall, refer respectively to the way in which a visual text is constructed to engage the viewer's gaze and direct it around and through the work and its various episodes, and the way in which formal elements permit a work to operate as a cohesive and coherent text. At the level of the whole work or picture, *Picnic Figure and Child* presents the viewer with a seemingly familiar setting, the apprehension of which is dependent firstly on the communicative information of the title of the work along with the force of *gestalt* drive – an inherent human tendency to seek out patterns and coherent wholes in encounters with marks.

The upper half of the painting contains a canopy of trees under which there is a small, white and barely discernible figure. It is principally through the title of the work that we may confirm that it is the figure of a child. In the foreground of the painting, there is what may be construed to be an arm caught in a grid-like structure, part of which may also be read as the torso of a larger 'headless' figure from which the vague idea of a second arm at the left side of the figure emerges. A roughly circular pattern of lighter marks form a track which leads back to the sheltered area, passes close to the figure of the child and goes beyond it to a dark mass invading the top of the scene above the canopy of trees. The track of rougher marks operate representationally by setting up a narrative between the figures – perhaps suggesting a game being played by the actors in the scene – and modally as a path directing the viewer's gaze in a circular sweep joining the two distinct and major episodes or areas of action in the painting. The larger figure appears in a standing pose, but there is also a sense of movement, producing ambiguous relationships between

this episode and the episode closer to the top of the picture. For example, it is difficult to establish whether the smaller figure is being repelled or attracted by the figure running away from or towards the dark shape at the top of the picture. The effect is intensified by the close relationship between the lighter colour of the 'track' marks and the arm. The latter operates modally, directing the viewer's eye-work in both a clockwise and anti-clockwise movement and has an effect rather like that created by the cinematic technique of speeding up and alternating forward and reverse projection. This lighter colour, which operates representationally to realise the arm of a figure and a track or path, also operates modally to direct vision. Compositionally it sets up rhythms between the two episodes and maintains interplay of arrest and movement at the level of the figure. This unsettles the narrative relations triggered in my first glance at the work and its title, impelling further investigation.

At the left-hand side of the work, the scene is cut off from view by the artist's use of framing, which produces the effect of the photograph that has been shot off-centre, reminding me that framing not only brings objects into view, but also operates as a repressive mechanism in its refusal of what lies outside the frame. At this point of analysis, it becomes apparent that neither the signifying apparatus of the work nor the structure of the functional semiotic model is able to establish a set of fully commensurable meanings. The remainders or excess produced in the acts of making and the acts of interpreting are evidence of the semiotic disposition or the operation of the X function inherent in the signifying systems of the work *and* in the structure of the interpretive model, suggesting that there is more to the work that is immediately communicable through the application of the rules of visual language.

Let us return to a further application of the representational function to illustrate the point. The representational function in the central episode of *Picnic Figure and Child* suggests a small

figure of a child with its arm stretched out, but again because of the refusal of the conventions of landscape and figure painting – the foreshortening of spatial relations and the artist's minimalist approach – it is difficult to tell whether the child is facing the larger figure in the foreground or holding its arms out in the *opposite* direction. At the level of members or elements representing parts of the body, the larger figure may be taken synecdochically, to represent woman or mother. Linked to the figure of this child, this may evoke associations of Madonna-and-child paintings, a view that is supported with recourse to modal and compositional functions. The track of light marks can be said to direct the viewer's gaze from the mother figure in the foreground to the darker mass near the top of the work, where the track of light is intercepted by the vertical line of the tree trunk in the centre of the work, diverting the gaze to the smaller figure of the child. Moreover, the light blue/white colour of both forms operates compositionally to link the two figures. However, the operation of 'negative' compositional features – the lack of coherence and alignment of objects, decentred framing and conflicting actions – produce ambiguity and a sense of ambivalence. The work's denial of conventional perspective and scale disrupt representational and narrative coherence, particularly where the three functions overlap and produce conflicting effects. For example, the 'headless' figure in the foreground does not conform in scale to the figure of the child or the trees. The 'invading' mass at the top of the picture is monolithic, much larger again than the figure in the foreground, and dwarfs the trees beneath it. This interplay of the different levels of modality and between different episodes, as well as the flattening out of the scene, gives the work a surreal or dreamlike quality, shattering any prior expectation or sense of order produced in my initial reading, one that was influenced by the title of the work.

This sense of instability is intensified by figure/ground relationships. Two thirds of the ground area towards the front of

the picture is considerably darker than the area beyond the trees, and conveys a sense of firmer ground. However, there is a clear division between the two areas; the upper third of the work is composed of thin light paint, suggesting vastness and unfamiliarity. The *chiaroscuro* mass that dominates this space produces a sense of threat or menace and increased confusion. In practice and interpretation, a conscious engagement or focus on marks in order to articulate an effect related to gaze may produce unpredictable effect in terms of representational or compositional coherence; hence the implication of the unconscious may account for the contradictory interplay between modal and compositional functions. Compositionally, the colour and lines of the arms produce some degree of coherence by linking episodes in the work, while the large dark mass disrupts coherence. A sense of precariousness is further intensified in the viewing of this work where framing operates both modally and compositionally to produce additional contradictions. At best the viewer is able to realise a number of partial readings, but is unable to cohere the various episodes created by the spatial relations operating in the work.

In Rowley's work, the operation of negative features, which occur at the overlap of the three functions of the semiotic model, severely taxes the viewer's ability to produce a single or cohesive reading. My engagement with *Picnic Figure and Child* highlights how an encounter with artworks trigger desire and a striving for meaning, a striving that in turn produces the tension and release of tension – and subsequent pleasures and displeasures of aesthetic experience. The realisation of negative effects in my application of the three functions of the semiotic model used is indicative of an unconscious alternative code, or the heterogeneous articulations of the semiotic disposition of visual language. This subverts existing systems and codes of landscape painting, while at the same time enlarging the semiotic space by suggesting a range of possible meanings hitherto not anticipated by conventional codes.

Feminist practices attempt to reconceptualise meanings that have become solidified in art history and criticism, and which have tended to operate from a predominantly 'public' and male perspective. Rowley acknowledges that her work is an attempt to present a view from the 'other side', from the particularities of her own lived experience. Her manipulation of the substance of paint is an attempt to instantiate a specific bodily presence in the work and at the same time aims to question the traditional view of painting as a male act. Although motivated by a specific set of intentions, Rowley recognises that there is an unconscious dimension at work in her practice. She points out the difficulties of moving in and out of the zone of actual performance and production:

You see, you paint to find out what you don't know...Otherwise you wouldn't do it...you can trace each moment when it comes together into whatever it is...the problem with describing what you

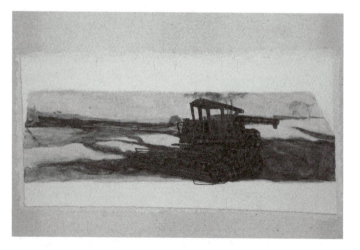

2. Linda Banazis, *Harvester*
(1993), oil and gesso on canvas.

do, is that once you describe what you do, it solidifies into theory, it's no longer useful...The next painting you make, you know nothing again. (Rowley 1993: 3–4)

Rowley's comments reveal that practice, as an engagement with and critique of the symbolic and its discourses, articulates a traversal between the known and unknown. This is in accord with Kristeva's account of the workings of negativity-rejection and the movement of subjective processes between unconscious material process and the constraints of the symbolic order. Rowley's observation also indicates the significance of practice as the production of knowledge. Apart from its capacity to critique the constraining influences of institutional art discourses, Rowley views artistic practice as a means of reconstituting experience that would otherwise be lost. We are concerned now with how the structuring of the work emerges from the artist's particular history and experience, which in this instance is related to her interest in the interaction of bodies in close proximity. She explains that the circular track in *Picnic Figure and Child* is an attempt to recapture 'the experience of sitting next to somebody and feeling that charge' (Rowley 1993). This account of the work is not so far from my initial observation that the track marks in the painting seem to work modally and compositionally, to link the two human figures in the scene. Juxtaposed with my own analysis, Rowley's comments suggest that while some de-specification of particular meanings is inevitable in interpretation, there is also a potential for the artwork as material and signifying *process* to realise (at least to some degree) transference of experience from artist to spectator.

Practice and laughter

A consideration of two landscape paintings by Linda Banazis exhibited in 1994 at the Gallery Dusseldorf, Western Australia will extend the current discussion of the workings of the semiotic disposition of visual language and what I have called the X

function in interpretive practices. Banazis's work is exemplary in its articulation of what Kristeva has theorised as the connection between laughter and practice, or more precisely between laughter and heterogeneous contradiction. This is so whether there is an overt production of humour or not: 'The practice of the text is a kind of laughter whose only explosions are those of language' (Kristeva 1984: 223). Kristeva has observed that laughter is an inherent aspect of artistic practice because it designates irruption of the drives against prohibition, 'it is above all the "artist" who must accomplish in each of his actions, what the instant of laughter reveals to the philosopher only in rare privileged moments' (Kristeva 1984: 222–3). Combining a functional semiotic model with the additional X function in analysis of Banazis's work reveals how laughter, like *jouissance*, may be viewed as a symptom of rupture of the heterogeneous contradiction within the signifying practice. The application of this mode of analysis also serves to demonstrate that creative practice involves an embodied engagement with and through language by a speaking subject. In practice, a return to (visual) language subjects the signifying system to material and biological processes and brings about performative alteration of the system.

Harvester (Figure 2) is a 35 cm by 35 cm work made of oil and gesso on cotton duck. At first glance, one is confronted with a strip of gesso running across the middle of the canvas on which is represented a 'typical' and vaguely familiar rural scene. Dominating the central foreground of the landscape is an accurately constructed image of a piece of farm machinery that is strikingly incongruous in that the surface is painted over in a brightly coloured red and blue chequered pattern reminiscent of the familiar gingham of the summer uniforms of Australian schoolgirls and country tearooms. On the other hand, the size and solidity of the machinery threatens to eclipse the rural vista in which it sits. The contrast produced by the artist's juxtaposition of dark opaque and light transparent colours operates compositionally

to give an amorphous and blurred quality to the background landscape. This is intensified by the strong vertical and horizontal lines of colour by which the harvester is realised. Where the right-hand corner of the machinery falls beyond the frame of the coloured ground area, these lines produce a sense of movement. The lines forming the projection or reaper section at the front of the machine act modally to direct the eye towards and beyond the distant horizon at the top right-hand corner of the scene. Representational ambiguity is produced by this section, which resembles a machine-gun barrel, so that the harvester takes on the appearance of a military tank.

Colour and line operate compositionally and modally to separate the foreground figure of the harvester from the receding landscape in the background. Simultaneously they set up a dynamic interplay between the two episodes. As a viewer, I am aware that this is some sort of a visual joke; however, I am

3. Linda Banazis, *Ram*
(1993), oil and gesso on canvas.

also prompted to interrogate what appears to be a problematic relationship between the two episodes. Narratively the 'machine-gun barrel' evokes notions of military force, or perhaps the work is about the mechanistic domination of rural life and penetration of the natural landscape by technological culture. However, these initial thoughts or lines of interpretation are interrupted by what appears to be a trivialising or diminution of the menacing aspect of the machine by the artist's use of colour. The tessellated pattern of the harvester prevents a coherent reading along the lines of the earlier and provisional narrative. Compositional incongruity gives rise to humour and a sense of the ridiculous, but at the same time the tension and ambiguity it produces impels further engagement.

A search for an alternative set of meanings at this point directs me to consider the artist's unusual use of framing. Compositionally there are at least four levels of framing in the work: the perfect square of the 35 cm by 35 cm square of the canvas, the thin jagged edges of an initial undercoating of gesso, a thick and a more solid rectangular layer of gesso, and finally the 'incomplete' and irregular frame produced by the thin coloured ground area of the scene itself. Distortion is produced by the transposition from perfect square to the narrow irregular strip of colour. This is intensified when the left- and right-hand sides of the coloured areas operate compositionally to produce a diagonal plane, so that the entire scene appears to be slanted. These framing lines also act modally to force the viewer's gaze to the lower right corner of the painting, so that there is a sense of viewing the scene from a space off the coloured area.

This sense of being out of the picture is maintained by the line formed by the material thickness of the gesso that runs around the scene portrayed. There is a constant need or pressure to negotiate the white strip of gesso that acts as a boundary between the position as viewer and the 'reality' of the portrayal, between 'thing' presentation and 'word' presentation. Internally, this scene is

further divided and distorted by the strip of light yellow paint that runs diagonally across the middle of the work. This strip and further striations of the ground area with darker translucent colours again unsettles the representational coherence of the scene. Uneven diagonal lines together with the wavy lines of additional bands of darker orange and blue operate modally and compositionally to heighten the sense of instability of ground areas, so that the barely distinguishable trees in the landscape appear to be falling over. Viewers who are familiar with landscape paintings of the Heidelberg era, and in particular the work of Arthur Streeton, will become aware of the parodic effect realised by Banazis's manipulation of perspective, framing and other formal conventions to distort what at first might have been recognised as a familiar scene painted by Streeton. To grasp the underlying impetus of this parody and critique, let us turn to similar effects realised in a second painting by Banazis entitled *Ram* (1993), which is also a critical reconstruction, this time of another Streeton work, *The Selector's Hut* (1890).

In *Ram* (Figure 3), techniques of multiple framing again operate modally to manipulate the reader's gaze, but compositionally to distort the perspective and proportion of the original upon which it is based. The central coloured area of Streeton's portrayal is reduced by Banazis's angling of vertical framing lines so that the lower horizontal line denoted by the coloured edge is at least one third greater in length than that of the upper horizontal line of colour. The transposition of Streeton's scene from a rectangular to a polygonal frame produces a concertina effect, squeezing everything towards the centre of the canvas and leaving a much larger area of unpainted gesso at the top and bottom of the landscape depicted resulting in a further disruption of Streeton's use of perspective. The 'space off', made up of thick gesso underpainting, is proportionally much greater than that found in *Harvester*, while the thinner irregular edge of the gesso resembles that of the earlier work, as discussed. In *Ram*, the representational

reality is diminished and distorted by the artist's use of gesso and colour as a double framing device. As was the case in *Harvester*, the original scene is also disrupted by the dominating presence of an added figure. In this work, the outsized figure formed by the irregular wavy bars of white paint takes up most of the bottom half of the represented scene, and also spreads out over a large area of the white border of gesso towards the right of the work. It is only with the aid of the title that I am able to distinguish the marks as the figure of a ram. The white marks work representationally to denote the figure of the animal, but compositionally and modally they refuse such a reading by focusing and directing the gaze into a circular sweep of the white unpainted section of gesso. This becomes an area of dynamic movement and action, diverting the viewer's attention away from the representational reality of the coloured episode. Tension is produced by the irregular and incomplete pattern of the white marks, which are barely distinguishable from the white gesso background on which they are made. Hence the marks serve a predominantly modal function, reorienting the interpretive process towards the material presence of paint as the artist's labour. Once again the artist's manipulation of formal elements and familiar images produces parody and humour, but also a sense of uncertainty and ambiguity. The 'male' figure in the scene is diminished and rendered ridiculous by the enormous presence of the ram realised by the artist's distortion of scale. Banazis' painting ruptures the codes of Streeton's earlier works and as visual 'poetry', generate a polyphony of additional meanings.

Kristeva tells us that the laughter of the one who produces that laughter is always 'painful, forced and black' because the prohibition that it lifts and the prohibition that is restored and necessary for the articulation of the communicable utterance (a text or artwork) weigh heavily on the artist (Kristeva 1984: 224–5). We can appreciate this in the light of her account of the symbolic law as the repression. Banazis's practice is impelled by

what she views as the romanticised myths perpetuated in canonical artworks' historical accounts of rural life and the settlement of Australia. Her work is an attempt to reconstruct her own experiences as a farmer's daughter and to recuperate what she views as a denial of her own, and more generally of a female, presence in historical discourses that render the contribution of women on the land invisible or else confine it to the domestic space. She has had direct experience of the patriarchal system of exchange and inheritance by which women from farming families continue to be denied ownership and control of property. She points to the figures in her painting '…two rams, like father like son'. With the heavy transparent thumbprints that denote the rams in her painting, she inserts her own bodily mark.

Banazis's distortions highlight the way in which material processes are implicated in and operate through the codes of a prevailing social semiotic to construct specific ways of seeing. Her interventions are a refusal of and a resistance to the subjective constraints imposed by the representations in Streeton's works, and reveal ways in which such works are partially structured by absences. The detachment of the gaze from Streeton's images relates to a characteristic of anamorphosis, which aims to subvert certainties that are induced by illusionistic space, those that imply that such a space can be all-inclusive. Banazis inserts herself into Streeton's landscapes via her embodied engagement with the materiality of paint.

My application of O'Toole's functional semiotic model together with the X function in looking at these works has involved an application of the method Kristeva refers to as 'semanalysis'. We can conclude through this mode of engagement that the 'negative' features in Banazis's works articulate her questioning of the reality and underlying ideologies represented in Streeton's paintings.

Semanalysis prompts the viewer to revisit and 'unfix' customary readings of canonical works. The operation of the X

function in Banazis's work is indicated by the way in which the works refuse a closure of interpretation. This refusal is one that the artist herself welcomes. Banazis expresses the pleasure she derives from the experimental and accidental dimension of her practice. Although she begins with a set of specific intentions, she is never sure where the act of making will lead:

I just place, put together already signified images, some of them altered for particular reasons, from a position I take as a woman and then see what happens with the interruption of painting… What I call it, is unease, sites of unease. (Banazis 1993)

These sites of unease are an indication of the semiotisation of visual language through the instantiation of the artist's embodied and affective processes into the fabric of the visual text. In the following chapters, we will look more closely at Kristeva's theorisation of affect and its relationship to art.

Chapter 3

Art and affect

In the 1980s Kristeva published three books that were primarily concerned with affect, a theme woven throughout her work that is crucial to understanding aesthetic experience both in the practice and reception of works of art. Chronologically, the first of the English translations to be published was *Powers of Horror: An essay on abjection* (1982) followed by *Tales of Love* in 1987 and *Black Sun: Depression and melancholia* in 1989. In order to maintain the trajectory of ideas presented so far, in this chapter we will consider key ideas in the two later books of the 'trilogy' before returning, in the next chapter, to a more extended exploration of abjection as it is theorised in *Powers of Horror*.

In *Black Sun*, Kristeva theorises melancholia as a structuring of psychic space and suggests that through creative practice, this structuring is in some way transferred to artworks. This is demonstrated in her analysis of the painting *The Body of the Dead Christ in the Tomb* by Hans Holbein. In *Tales of Love*, Kristeva turns to the positive affect, love, which she describes as a corollary of melancholia. In the two later works of the trilogy, melancholia and love emerge as two sides of psychic functioning that constitute the subject's relation to language, to self and to the social other. In the final part of this chapter, I will illustrate this relationship and its significance for understanding aesthetic experience by applying Kristeva's thinking on melancholia and love to my reading of the work of animation video artist Van Sowerine.

In a world of artificial experience and values promoted by ubiquitous media and consumerist images, imaginary capacities or psychic functioning are hindered, giving rise to what Kristeva describes as 'new maladies of the soul' (Kristeva 1995). In Western societies there is a growing sense of meaninglessness resulting in a greater incidence of melancholia and depression. When not depressed, the subject is swept away by valueless objects and perverse pleasures, but little satisfaction. As you will recall, Kristeva places psychoanalysis and art among the few means by which this crisis of subjectivity may be overcome. The amatory discourses of psychoanalysis and art have the capacity to engender self-love and love of others. Kristeva's account of melancholia and love are thus fundamental to understanding artistic production as a set of ethical practices that serve a crucial function in society. Aesthetic experience provides a means of overcoming the abstraction and depersonalisation of life in contemporary society, because it is predicated on a materialist ontology – the living body in connection with others – operating as an open system through which affect, thought and language are linked to real time, individual histories, experiences and values. The capacity of affect to attribute value in aesthetic experience is the central concern of this chapter.

In Chapter 1, affect was considered in relation to the heterogeneity of language elaborated through its two dimensions, the symbolic and the semiotic. Kristeva argues that for language to have meaning and value it must articulate our lived experiences and affects. Her aesthetics is concerned with the practices and processes by which bodily drives and affects are transformed into language. In order to appreciate fully the relevance of this for artists and art audiences, and indeed for those who may be interested in deepening an understanding of the arts in therapy, it is necessary, first, to understand what is meant by 'affect' and the way affect functions as a bridge between body and mind.

What is affect?

Affects emerge from homeostatic processes that regulate and maintain the efficient functioning of living organisms. Sigmund Freud draws on Charles Darwin's ideas concerning the origin of species to explain affect as a response that is tied to our earlier instinctual drives and emerges as traces of past actions – the baring of teeth is an example of this relationship. This link is the basis for the psychoanalytical view that affect is hardwired into the human biological system and has evolved as part of the human psychological condition. In 'The ego and the id' (1923), Freud tends to focus on negative affect. He observes that 'Sensations of a pleasurable nature have not anything impelling about them, whereas unpleasurable ones have it in the highest degree' (Freud 1923: 360). The implication of affect in aesthetic experience is what underpins the power of art to make us feel and act differently. It thus constitutes a form of agency. In Kristeva's thinking, both positive and negative affects have the power to impel us to feel something; as a consequence, it triggers processes that lead to verbalisation. Kristeva goes beyond Freud's 'antagonistic' account of affect by positing melancholia and love as functions of aesthetic experience that have the capacity to strengthen and renew social bonds. She describes affects as internal 'representations' or archaic energy signals, 'fluctuating energy cathexes insufficiently stabilized to coalesce as verbal or other signs' (Kristeva 1987: 21). Though not yet captured in symbolic form, these rudimentary signals are nevertheless linked to agency of the ego, and are inchoate precursors of conscious thought and language. These affective signals, or inscriptions which are implicated in processes that regulate internal states and maintain the organism's boundary and living processes are biological antecedents of a sense of self or ego that emerges via the symbolic.

As internal states that occur naturally along a continuum of pain and pleasure, affects subsequently become the 'unwitting' non-verbal signifiers of 'goodness' or 'badness'. In his description

of creative writing as 'the mode of Eros' (and this may be applied to all creative practices), Roland Barthes observes:

the affectivity which is at the heart of all literature includes an absurdly restricted number of functions: I desire, I suffer, I am angry, I contest, I love, I want to be loved, I am afraid to die – out of this we must make an infinite Literature. (Barthes 1972: xvi)

Kristeva theorises affect as an aspect of *pre-verbal* processes at work in aesthetic experience, and this emphasises the distinction between affect and emotion. Antonio Damasio also makes this distinction in his account of the relationship between biological processes, affect, emotion and conscious thought. He notes that emotions are collections of non-verbal responses, which can be outwardly observed, whereas feeling or affect is an internal experience which is poised at the threshold between being and knowing (Damasio 1999: 42). This is a state in which one may have feelings that have yet to be expressed as recognisable emotions such as sadness and happiness. Though the processes involved in transposing affect to thought are not fully understood, Kristeva's work indicates that affects attribute value to experience and can lead to verbalisation, association and judgement. In terms of the overcoming of melancholia, she describes this process as the work of mourning – the means by which affects can be reconnected to the symbolic.

Why melancholia?

It is often the case that great works of art emerge from conditions of adversity or alienation. Why is this so? Kristeva tells us that melancholia is a *precondition* for creative production. When the semiotic and the symbolic are not connected, language, communication and hence social bonds lose meaning and value. As a subject beset by melancholia, the artist is a witness of the signifier's flimsiness or its inadequacy

to register emotional valency, but unlike the depressed person, the artist struggles with language in order to forge new meaning out of the melancholic condition itself. Here, the negative affect, sadness, is the impelling force. This is the basis for Kristeva's view that art can be understood as the work of mourning. To grasp this, we need to examine her account of melancholia as a crisis of subjectivity originating in the infant's first relationship to the mother and its necessary separation from the mother in order to develop as an ego. Upon losing the mother, if the child is to develop an ego, it must retrieve the mother as a sign, image or word; it must generate language.

The question of how subjectivity is constituted thus turns on the individual's capacity to overcome the loss of the mother. This allows the child to become a social being, to be connected to social others and to develop an ego based on identifications with ideal others. The process involves overcoming what psychoanalysis has theorised as the depressive phase of development in order to move from a love of self (narcissism) to love and relations with others. Prior to its entry into language, the child's libido is directed inwardly towards the 'thing' or the maternal object defined in *Black Sun* as 'the real that does not lead itself to signification, the centre of attraction and repulsion, the seat of sexuality from which the object of desire will become separated' (Kristeva 1989: 13).

Separation from the first object, the mother, signals the onset of the depressive stage, where satisfaction and the fullness that results from union with the mother is replaced by a sense of loss or emptiness. This is essential to the child's access to the realm of language because 'lack' is necessary for a sign to emerge. How can lack be registered or inscribed prior to language? Kristeva explains this in relation to the functioning of affect, the most archaic inscription of inner and outer events, the earliest examples of which are registered in the child's separation from the mother. This primary inscription is related to the drives, and

occurs as bodily or somatic responses that produce a psychical action cutting across the auto-eroticism of the mother–infant dyad. In order to understand this fully, we must negotiate what is often misunderstood in Kristeva's thinking – the notion of primary identification with the 'imaginary father'. This relates to aspects of her work that departs from Jacques Lacan's account of the development of the ego. Before proceeding, it is therefore worth revisiting Freud and Lacan to extend my earlier discussion of some crucial differences in the thinking of Kristeva and Lacan. You will recall Freud's account of the psychical apparatus and its agencies in terms of the id, the site of the drives and the organism's instinctual processes related to nourishment, sexual attraction and aggressive self-protection (the pleasure principle); the ego, responsible for reconciling the demands of the id with social demands (the reality principle); the superego, sometimes understood as 'conscience', but which involves a partly unconscious interplay between the id and the ego, a functioning that works to maintain internalised imperatives of social norms.

Lacan reconceptualises Freud's categories to emphasise the way the ego or subject emerges in relation to language, and in relation to the social other. He conceptualises three phases or dimensions of this process: the imaginary, the symbolic and the real. The imaginary or 'mirror stage', which occurs at between six and eighteen months of age can be understood in terms of the child's relation to *images* rather than language, and the infant's misrecognition of itself as a totality or full body in the 'mirror'. The virtual image of self in the mirror is mistaken for reality. The 'mirror' also relates to images of the mother and immediate others in the child's early life prior to the acquisition of language. At first, there is inadequate separateness because the child misrecognises or mistakes what it sees. Others are misrecognised as self – as not being distinct from self. The image therefore, is a phantasm – an object of internal psychic reality that the child reacts to *as if* it were a part of external reality.

Noëlle McAfee explains: 'In the imaginary, the infant does not distinguish the truth or fiction of its images, symbols and representations. It takes all its internal representations to be real' (McAfee 2004: 33).

It is upon this apparatus that what Lacan refers to as the ego ideal is formed. The ego ideal can be understood in terms of the structure Freud describes as 'primary narcissism' – the love of self prior to separation, where self is felt to be continuous with the mother – that the infant experiences before learning to love others. Alienation sets in as the child begins to apprehend its separateness from the mirror image. There is a fragmenting of the image of self as other (the ego ideal), as the child begins to differentiate from its m/other and to recognise that it cannot fashion itself with respect to its imaginary images. This may also be understood in terms of a loss of immediate gratification – a gap between need and satisfaction, and at the same time a recognition of the mother as lacking, since the mother is unable to fulfil every need.

At this stage, the child produces sounds and uses objects that are *imaginary* equivalents of what is lacking. It is in this sense that we can appreciate Lacan's observation that the unconscious is structured like a language. In Lacan's framework, 'alienation' in the mirror stage gives rise to a splitting of the ego and identification with the father. The formation of the subject and development of the ego ideal occurs as a consequence of the child's entry into the symbolic and its relation to the broader arena or social other. Attempts to overcome the gap, or lack of gratification, are thus predicated on an already constituted notion of difference. That is to say, the subject is constituted through *secondary* processes and identifications. Love of self or primary narcissism, a state in which energies and drives are directed towards the self, gives way to secondary narcissism or 'healthy' narcissism, a state in which the child's energies and libido are directed towards external objects and it is able to

develop an identity or ego via idealisation and identification with (external) social others. In Lacan's account, the subject emerges as a consequence of a *split* between the imaginary and the symbolic realms, but is structured by the symbolic, *not* the imaginary realm. From this aspect of Lacanian thought emerges the conception of 'lack' and of the phallus as the primary signifier underpinning the structure of symbols, differences and laws. In Lacan's schema the emergence of the subject also results in a foreclosure of the real as an anteriority to which we can never return. His conception of desire thus turns on the notion that language and the symbolic are inadequate or partial substitutes for what has been lost. How does Kristeva's account of the emergence of the subject differ from that of Lacan?

The first difference between the two thinkers relates to their respective views concerning the time at which the infant begins to differentiate itself from its mother. Kristeva contends that this occurs earlier than the mirror stage, and within the maternal realm, the chora, where the infant's energies and psychic space are constituted in relation to the mother as primary care-giver. At this stage a distinction between self and other has not yet developed and the mother is not yet an object for the child. It is nevertheless a space in which the child begins to learn the ways of the symbolic. Although this phase may be conceived of in terms of Lacan's imaginary, from which the subject will be split on its entry into language, Kristeva argues that traces of the imaginary are carried over into the symbolic and constitute an alternative stratum of subjectivity. In other words Kristeva says that *primary* narcissism and *primary* processes are also implicated in subject formation, and it is here that the concept of the 'imaginary father' requires explanation.

Negation or loss of the mother begins in the imaginary realm as the child begins to incorporate and mimic what is other to itself. This produces a phantasm of the logic of identifying one thing with another (McAfee 2004: 67). In primary narcissism a

triadic structure emerges when a new psychical action impinges on the auto-eroticism of the mother–infant dyad. This logic or structure may be understood as the 'imaginary father'. Kristeva draws on Freud, who explains that this action consists of the first and most important identification: one that is 'immediate, direct and anterior to any object cathexis' (Freud 1953: 31). It should be stressed that the imaginary father is a *maternal* structure of the mother's love (for example, discerned through facial expressions and nurturing sounds), and comes about when the infant senses or gives face to the indeterminable marks of the mother's care, also an indication of the mother's love – and as the child begins to apprehend moments of the mother's absence or turning away from the child – and in doing so, 'is able to signify herself to her infant as having a desire other than that of responding to the demand of her offspring' (Kristeva quoted in Chase 1990: 126–7).

It is this process of identification, which produces a gap or the emptiness of primary separation. This structure that emerges is not yet a sign, but a figuration that is a precondition for the emergence of a sign. It can be understood initially in terms of biological or material processes – as feeling or affect, and its significance for understanding melancholia will become clear presently. The figuration or identification with the imaginary father produces the structure of sign, and in this sense primary identification can be understood as the performative dimension of language that is anterior to and continues to operate beyond the cognitive function of language. It indicates the semiotic or heterogeneous dimension of language that continues as an inseparable dimension of the symbolic. Desire in the field of this semiotic dimension articulates with love and connectedness that are necessary for social bonding and operate alongside desire in the field of the symbolic, where object and subject are separated. As we have already seen, Kristeva's account of the *semiotic* as a heterogeneous functioning is an indication of the

materiality of language and is the basis for her view that the real is not totally inaccessible. This leads to a second point of departure from Lacan, which can explained through her conception of *abjection*, a complex and nuanced concept to which I will return in the next chapter.

Fundamentally, abjection refers to processes of expulsion necessary for the establishing of borders between the 'I' and the other. In her account of abjection, Kristeva theorises primary processes in relation to *material* processes. Abjection is an archaic or very early process that arises from the infant's relation to the mother, even before birth, where biological processes are at work laying down the conditions for the child's separation from the mother; it ensures the differentiation between mother and child before birth. In *Powers of Horror*, Kristeva describes abjection as a 'vortex of summons and repulsion' that maintains the border between life and death, chaos and order – a border that must be established for a subject or ego to emerge. Abjection is implicated in drive-ridden processes and is therefore a functioning that is pre-oedipal and pre-imaginary; as an aspect of biological functioning, it prevails throughout the individual's life. Through her elaboration of abjection, Kristeva extends Freud's account of narcissism and its relationship to melancholia and love.

The gap or bar that emerges in primary identification does not produce a subject and an object, but the 'phallus' (a mark indicative of something other than plenitude and unity with the mother) – and an 'abject'. Abjection can be understood as an expulsion or rejection of the mother, and also as a rejection of chaos *prior* to the emergence of rudimentary significatory marks. However, this 'rejection' and the notion of abjection cannot be viewed simplistically. In rejecting the mother, the child is also rejecting part of itself. In terms of the more archaic separation, abjection is also implicated in maintaining a border between the child and the womb – a place of plenitude and comfort that must

eventually be jettisoned in order for the child to live. There is always a pull towards this prior state; hence abjection prevails as a lining of consciousness – as a fearful drive towards a state of non-differentiation. Throughout life, abjection prevails as a process of attraction and repulsion necessary for the performative production of language to occur and for any erotic object or object of desire to emerge. It is in this sense that abjection is implicated in melancholia and artistic production. In melancholia there is an inadequate separation; the melancholic internalises the maternal object. Artistic production is the struggle to overcome this condition by expanding symbolic capacities.

In *Black Sun*, melancholia is described as an 'impossible mourning for the maternal object' (Kristeva 1989: 9). Kristeva's theorising of the subject as a continuum between bodily processes and language leads her to suggest that it is not crucial to establish the distinction between melancholia and depression. The former is generally considered to be a condition that is irreversible without chemical antidepressants because it relates to internal trauma, is endogenous in origin and may be related to biological malfunctioning, whereas depression is understood as a condition that emerges as a result of external events in an individual's life, 'to echoes of old traumas to which I realize I have never been able to resign myself' (Kristeva 1989: 4–5). The blurring of boundaries between biological and mental states can be seen in depressed persons who also suffer physiological symptoms. For Kristeva, it is not necessary to establish whether melancholia and depression arise out of the failure of the symbolic or out of biological impairment, because in both cases there is the same impossible mourning for the maternal object. How can this observation take us closer to an understanding of the relationship between melancholia, love and art?

In the case of the infant, separation from the mother can be overcome if she is partially recovered through language. Primary inscription of loss results in emptiness and the child's parting

sadness. This emotion emerges from affective responses related to energy disruptions and the movement of drives that are not simply raw energies. These energy disruptions and the affective responses they engender give rise to mood and point towards a modality of significance which is not yet symbolic, but necessary for objects to emerge and for connection and identification with social others to occur. Negation of the primary object (the mother) and acceptance of loss is made possible when the child is able to use language – when the pain or anguish of loss is symbolised and there is at least a partial recovery of the mother through words. Here, Kristeva's use of the term '*dénégation*' allows us to grasp the relationship between melancholia and love:

> Signs are arbitrary because language begins with a *negation* (*Verneinung*) of loss, along with the depression occasioned by mourning. 'I have lost an essential object that happens to be, in the final analysis, my mother,' is what the speaking being seems to be saying, 'But no, I have found her again in signs, or rather since I consent to lose her I have not lost her (that is the negation), I can recover her in language. (Kristeva 1989: 43)

Dénégation implies both a negation and disavowal of the mother ('I have lost her'), but is also an implicit affirmation ('I can reconnect with her through language'). This term is a key to understanding Kristeva's idea that language is made up of both imaginary and symbolic elements. What is the source of this affirmation other than the imaginary *image* of the mother's love that is released into language as affect – as the semiotic? The semiotic dimension of language assures some consolation is available through words because primary identification grafts the image of connectedness to the signification that marks separateness.

Let us return for a moment to the infant who has not yet entered the symbolic. In this phase the mother is taken to be part of the self – mother's love is therefore self-relation, self-love

predicated on fusion. At this stage the child desires an object outside itself, but is still captive to imaginary images or phantasms that constitute the ideal ego – primary narcissism. Here the child is not yet able to translate or transpose these images to external objects and others. Entry into language permits the infant to accept that the mother exists and that the mother's love and desire for the child remains even if she is absent or her face is turned away. In Kristeva's thinking, language constitutes a connection between child and mother only because this imaginary structure of primary identification and love (affect realised as the semiotic) is carried over into language. The development of the ego is the development of 'healthy' narcissism that permits love of the m/other as separate from the self; in other words it establishes social relations and social bonding while *at the same time* accommodating the immediate identification that occurred prior to object loss. This is made possible by an anterior process of expulsion of the archaic mother (the thing or the abject). We can say that through its entry into language, the child/subject is able to tolerate loss and to let the m/other *be*. This occurs through the ongoing interplay between material processes, imaginary processes and the symbolic – processes which allow the signifier to emerge and to compensate for loss.

In melancholia this does not occur. The individual is stuck with affects that are inexpressible because of an inability to accept loss and separateness. Hence the necessary graft between the semiotic and the symbolic fails to take hold. In this condition the libido is directed inward and linguistic capacities are impeded; signifiers lose their meaning and value, and the individual becomes detached from social others. What is emphasised here is the idea that the basis of melancholia is an intolerance for object loss, and hence an inability to love or to connect with others through language. This aspect of Kristeva's account of melancholia is most relevant for understanding affect as it relates to aesthetic experience.

In depression, primary identification is fragile and insufficient to secure secondary identifications which are symbolic and which produce erotic objects or objects of desire. Instead, there is a desire for a pre-object, the archaic other, or 'thing' that refuses representation. This is the opposite to love because love gives rise to representation through sublimation, as I will explain in more detail in a later chapter. Kristeva views melancholia as mourning for a partial loss which cannot be symbolised – as an uncommunicable grief. The depressed person experiences emptiness and lack as fluctuating energy investments – as affect; *dénégation* does not occur, and consequently the individual becomes a prisoner of sadness: 'For such subjects sadness is really the sole object; more precisely it is a substitute object they become attached to, an object they tame and cherish for lack of another' (Kristeva 1989: 12).

Hatred and violence

Along with sadness and grief, the depressed person is also often assailed with feelings of hatred and aggression, because as soon as an 'other' appears different from the self it becomes alien, repelled, repugnant and hated. Kristeva refigures Freud's notion of death-drive by linking it to early inscriptions of exteriority that occur in bodily exchanges between mother and child and that give rise to abjection. 'Death drive, then, marks the *violence* of the impact of want-loss' (Beardsworth 2004: 76). The ambivalence towards the lost object in depressed persons becomes clear in Kristeva's account:

'I love that object,' is what the person seems to say about the lost object, 'but even more so I hate it; because I love it, and in order not to lose it, I imbed it in myself; but because I hate it, that other within myself is a bad self, I am bad, I am non existent, I shall kill myself.' (Kristeva 1989: 11)

The casting of the archaic mother as an object of fear, loathing and hatred has been played out in patriarchal religions, discourses

and art in ways that associate the maternal with the impure, uncanny and monstrous. It is against this backdrop that Kristeva's account of the maternal is often read. Barbara Creed suggests that Kristeva's theory of abjection can thus often be interpreted as 'an apology for the establishment of sociality at the cost of women's equality' (Creed 1986: 54). However, Creed goes on to argue that if Kristeva's account of abjection is read not as an apology or acquiescence to this positioning of the maternal, but as a *descriptive* account that attempts to explain the origins of patriarchal society, we may understand representations of women in a different light. Adopting Creed's supposition can also help to shift the interpretive focus to those aspects of Kristeva's work that indicate the generative and recuperative functioning of abjection and the maternal. While the melancholic individual is beset by hatred of the lost primal object, the introjected m/other, it is nevertheless via elements of this very maternal function that the depressed person can recover and be returned to a state of love and connection. As Kristeva has shown, artistic production is one of the means of achieving this by reinvesting the symbolic with affect, allowing the complementary functioning of the semiotic – the maternal in language – to operate; this is indispensible for language or the law-of-the-father to have meaning and value.

Psychoanalysis, melancholia and art

Kristeva contends that psychoanalysis acts as a counter-depressant because it is able to shed light on the inadequate anchoring of the semiotic in the symbolic. The working through of real or imagined traumas in therapy results in a renewal of the individual's imaginary and symbolic capacities, allowing the patient to give voice to inexpressible grief. It is this aspect of the so-called 'talking cure' that provides a basis for drawing parallels between psychoanalysis and art. Psychoanalysis and art provide an indirect way of approaching and negotiating the maternal thing that has not been successfully expelled. In the psychoanalytic

process, interpretation adopts the psychological profile of a question and confronts patients with what they don't know: 'By giving name to that which cannot be formulated, I put it into a question. I make an affect into a question; I elevate sensation to the understanding of a sign' (Kristeva 1995: 89).

Although Kristeva acknowledges the oedipal structure as fundamental to the psychoanalytical process, she repeatedly notes that contemporary psychoanalysis is by no means normalising or normative. She says that if psychoanalysis were only contingent on the choice of sexual identity, and a way of guiding patients towards social success, it would simply be a mechanical exercise. The end of analysis gives rise to a vast array of questions prompting a certain creativity – a counterbalancing of truth and *jouissance*, authority and transgression. As a result, 'psychoanalysis upsets the social contract' (Kristeva 1995: 35). What, then, distinguishes the making and viewing of art from psychoanalysis, and the depressed patient from the artist?

Kristeva's analysis of artworks shows that loss and death have a history, and that art operates as mourning in relation to the specific context in which it is made. Art is a practice that constitutes the discourse, not of psychosis and neurosis, but of subjects that are alienated in their language and blocked by their history. Because there is little or no separation between the artist's life and his or her work, the locus of art is language itself – as a mode of production with highly diversified and multiplied manifestations (Kristeva 1980: 97). The motivations, concerns, technical means and varying modes of symbolisation in artistic practice are testimony to this. However, as was shown in the first chapter of this book, at the centre of all creative production is the subject as a process that is constantly making and unmaking itself. Kristeva's theory of melancholia and abjection furthers our understanding of this. The artist is melancholic because of an attachment to the thing, an aspect of reality that resists symbolic expression.

Post-Enlightenment society is characterised not only by an undermining of the discourses and practices of religion, magic and myth but also by the depersonalising influence of bureaucratic organisations; this, together with failure of extant discourses and modern institutions to account for lived experience has resulted in a prevailing nihilism and tendency towards melancholia. In contemporary Western society 'new maladies of the soul' have emerged in response to the empty spectacle and bombardment of readymade images. The excessive demands of consumer culture and the speed and distraction of contemporary life leave little opportunity for nurturing imaginative capacities. This has resulted in a 'severing' of the semiotic and the symbolic, and as a result a growing incidence of depression.

If art remains one of the few means to countervail this condition, speaking and writing about melancholia can only have meaning if what is produced springs out of that very melancholia. Hence, for the artist it is not a matter of illustrating grief, but of making an artwork out of it, and in doing so restoring and renewing the subject and interpretations of experience. The artwork provides a site for this process to be extended to viewers and audiences. Art as the adventure of body and signs bears witness to affect and turns it into rhythms, signs and forms so that the semiotic and the symbolic 'become the communicable imprints of an affective reality, perceptible to the reader' (Kristeva 1989: 22). This is illustrated in Kristeva's analysis of literature and art in *Black Sun*, and in particular her account of Hans Holbein's painting *The Body of the Dead Christ in the Tomb*, to which I now turn.

Death and resurrection through art

Holbein's painting of the dead Christ is an instance of mourning that also reflects social-historical conditions of the artist's time; it is an artist's response to the severe religious dogmas of the Protestant Reformation, as well as (paradoxically) a moment when beliefs of Christianity had begun to give way to the rational

discourses of science and secular society. The work is an externalisation of Holbein's personal sense of alienation and subjective crisis and the artist's struggle to find the means for expressing and overcoming a sense of suffering and loss. Kristeva's interpretation of the painting highlights the complex interrelationship between melancholia, art and revolutionary practice. Her analysis of this painting traces how creative texts articulate a movement between the individual and the wider political arena. It reveals the process of subjectivity as an interplay between biological or material processes and institutional discourses. Holbein's painting marks an embryonic emergence of a minimalism in art that was later to become a feature of Modernism. His work illustrates how the overcoming of suffering and melancholia through art involves a transgression of the law of the symbolic and a renewal of its capacities.

The vision of death without redemption in Holbein's painting arises from the artist's personal crisis; it is also an aesthetic response to the repressive discourses of the Protestant Reformation, and in particular the Calvinistic view that in punishment, suffering and deep repentance there is little hope of human redemption. The Reformation also marked a resurgence of iconoclasm, the banning of all images, including objects and sacred music, as forms of idolatry. Holbein's Germany had become alienating to the painter, who fled to England, where he continued to paint. Although the deprivation and minimalism of religious expression had a strong influence on Holbein's style, his refusal to abandon the image altogether was nevertheless transgressive. His work can be understood as the conveyance of a depressive moment related to the unsettling events of his time. The painting in question can also be read as a working though and overcoming of melancholia, resulting in the emergence of a new way of painting that would have a lasting influence.

Holbein's depiction of the dead Christ departs from traditional representations found in Gothic and Italian iconography. While the

former drew heavily on compositional resources of realism to emphasise the horrors of death and hell, the latter resorted to ornate adornment, emphasising resurrection and transcendence. Holbein's dead Christ does show evidence of the more sobering influence of crucifixion paintings by Matthias Grünewald and Andrea Mantegna. However his minimalism and the absolute isolation of the body of Christ sets this image apart. Kristeva describes the work as a 'composition in loneliness'. There are no mourners to convey a sense of compassion; the body is stretched out horizontally as if on a mortuary slab and is separated from the viewer. The head is bent back and slightly twisted, the face smashed and bruised, and the mouth and eyes are still open. Drawn into the claustrophobic space of the crypt, the viewer is confronted with an image of death as inescapable, a death with no sign or hope or transcendence (Lechte 1990a: 36). This is further emphasised, in *Black Sun*, by the allusion to Prince Myshkin's declaration in Dostoevsky's *The Idiot*, 'Why some people may lose their faith by looking at that picture!' (Kristeva 1989: 107). This reference to loss of faith in God relates to Kristeva's description of the depressed person as 'atheistic' – as one 'deprived of meaning, deprived of values ' (Kristeva 1989: 14).

Kristeva's interpretation of Holbeins's painting applies psychoanalytical insights to articulate the relationship between personal concerns of the artist and broader social and historical events. As Beardsworth observes: 'One dimension of Narcissus is the confrontation with pain, loss and death at the limit of the ties between the individual and the social, the specific topic of *Black Sun*' (Beardsworth 2004: 144). Compositionally, *The Corpse of the Dead Christ in the Tomb* exemplifies how art operates as both a symptom of melancholia and a site for the elaboration of loss. Holbein's minimal use of colour, the dark greys, greens and browns, the low and heavy vertical line denoting the ceiling of the crypt, evoke a sense of solid encasement. There is no prospect of escaping death as solitary separation. The pictorial resources of

realism available to the artist – the angle of the head, the sightless eyes and open mouth – are frugally applied to denote a body in the state just prior to the onset of rigor mortis. The stark isolation and lack of adornment of the scene is heightened by the way in which the corpse dominates the space of the crypt to the exclusion of anything that might link it to the outside. The viewer's gaze has very little to redirect or release it from the corpse, which is transformed into an abject, a melancholic thing that both attracts and repels the viewer. Holbein's minimalism maintains the movement between these opposing forces. The date of the painting and the signature of the artist placed at the feet of Christ, suggesting the humility of the artist, are sparse reminders that this is not death itself, but death represented by a sign. This detail is also an index of the life that produced the sign.

However, it is the detail of part of the hand and strands of hair falling just beyond the slab that works modally, and ever so minimally, to redirect the viewer's gaze beyond the space of the crypt. This indication of an 'outside' constitutes the bar or gap necessary for identification and separation to take place. The viewer, then, is able to apprehend Christ as the incarnation of death and to identify with Christ's suffering. The structure of the work engenders a viewing experience that gives rise to both introjection and expulsion of the body of Christ. While compositional minimalism results in indeterminacy, separation is made possible by the representational function of the image. The work can be said to provoke a passage to and from the real. Confrontation with the corpse gives rise to a wave of destructive drive energy, while representational elements permit a 'recovery' or *dénégation*. The latter is a different kind of transcendence made possible through the materiality of visual language and the recuperation it permits. Christ is dead, but he is not dead because he is recovered in the sign. In this sense, the painting is a work not about, but *of*, melancholia and mourning. Kristeva suggests that Holbein's minimalist style is a metaphor for the

scission between life and death, meaning and non-meaning. *The Body of the Dead Christ in the Tomb* is not simply an expression of the artist's subjectivity, but is constitutive of it. What appears in the painting is a sign of something that once existed for someone; hence the image constitutes the subject as both material and social process. Holbein's painting reveals art's capacity to reconnect the social subject to reality via material process and the semiotic; this is crucial to the renewal of subjectivity and to the warding off of melancholia. It does not imply collapsing the distance between reality and the sign, nor of arriving at a true representation of reality, but of pointing out that an original object of experience is an integral aspect of constituting viable subjectivity through aesthetic experience: 'To identify with a reality – to believe in it – to identify with another – to love another – is to accept the denegation of language founded on an identification which has a symbolic *and* a real basis' (Lechte 1990b: 348).

What is love?

Melancholia is a condition that impedes the emergence of the object. The individual clings to affect and is a prisoner of affect that resists being grafted to the symbolic. In the artist, this motivates a constant struggle to find a language that would allow an object to emerge. In the case of Holbein, sadness and loss result in the forging of a new minimalist style allowing the artist to represent death, and hence to overcome death through mourning. Holbein's new painterly vision was underpinned by a *necessity* to overcome the inadequacy of earlier art forms to accommodate a loss of faith in God and thus to renew meaning and value within the context of social and historical currents. His painting permits a recuperation through the grafting of negative affect (sadness) to the symbolic – a process that permits the *bringing forth* of a new *metonymic* object of knowledge. How does this differ from the art of love?

In *Tales of Love*, Kristeva weaves a picture of love as both a familiar experience and as a complex functioning of the human

psyche that occurs at the borders of subjectivity. She describes it as a 'risk of death and a chance of life'. As psychic process, love is reciprocal to melancholia. Love gives rise to a different crisis of subjectivity; art permits an overcoming of these upheavals and crises of subjectivity, and in doing so also renews and reinvigorates normalising discourse.

Kristeva describes the lover as 'a narcissist with an *object*' (Kristeva 1987: 33). Unlike melancholia, love implies an already constituted relation to another. In the state of love, however, there is also a fusion between self and other, which involves taking the other into oneself, *as* oneself. This occurs because in the speech between lovers there is an assimilation of the other's feelings or affects into oneself. The ideal other is introjected through processes of primary identification. In the child, this involves the development of the ideal ego, a loving relation to self that is predicated on the *imaginary* relation to the mother prior to separation and entry into the symbolic – a realm of maternal care and *jouissance* that gives rise to *positive* affects.

In love, there is a vertigo of identity, a vertigo of words (Kristeva 1987: 3). A metaphor allows us to experience and understand one thing in terms of another; in other words there is a fusion of the two in order to transfer an attribute of one thing to another: 'he was a lion in battle'. Baudelaire's 'perfume' works metaphorically at multiple levels. It is fusional because the scent of another merges with us as it is inhaled; moreover the scent of a loved one is experienced *as* that person within memory. Because the subject is under the sway of the imaginary, there is a temporary loss of ego; idealisation opens up to an objectless realm (the realm of the imaginary father/maternal desire) that is not yet judging or prohibiting. This gives rise to amatory discourse: the transgression and expansion of the symbolic through the proliferation of metaphorical language; this is a sublimation, not of aggressive drive and negative affect, but of idealisation, attachment and union with an object which

is also a striving for meaning within signs. In love there is a dissolution of self and other because ideal and affect come together – this is the fusion that constitutes the *metaphorical* object of knowledge and meaning. Love and the art of love are similar, in that both involve a relation to the other not as threat, but as an open system that leads to growth, renewal and change. In creative practice, as in love, the ego is given up in and for another; there is instability and risk, but acceptance of risk is also an affirmation of attachment to the possibilities of life, as opposed to detachment and a movement towards death. The movement between loss of self and recuperation of self is what links love and melancholia; the production of language in and through both processes can be understood as sublimation – the displacement or transposition of energy and drive into language. In melancholia, we can say that the thing or object is expelled and the violence of abjection is 'disaggressified'. Here, sublimation can be understood as a process involving the transference and redirection of instinctual energy as death-drive into language.

4. Van Sowerine, *Clara*
(2004), film still.

Perhaps this is why a great deal of contemporary art often appears to be dark and detached. This can certainly be observed in Holbein's painting of the dead Christ.

In the state of love, where the internalisation of the *erotic* object implicates *jouissance*, sublimation involves processes in which drive energy is 'desexualised' and positive affect is translated into language as metaphor. The work of Australian video animation artist Van Sowerine, entitled *Clara* (2004) provides a fitting vehicle for illuminating Kristeva's account of the relationship between art, love and melancholia.

Van Sowerine and the art of love

If, as Kristeva tells us, art performs the work of mourning, it could be argued that Holbein's *The Body of the Dead Christ in the Tomb* is a work of mourning that nevertheless emphasises detachment and separation. In this work, the realism is unadorned and lacking in any narrative or metaphorical detail that might move the scene beyond the artist's stark and solitary confrontation with death. Holbein's style ensures only minimal recovery; to look at this painting is to be poised at the edge of death, because we are cut off from signs that might connect us to life and to others.

Van Sowerine's work marks a trajectory between melancholia and love. A counterbalancing of the two is made possible by the various means made available through the manipulation of the diverse signifying resources of film and animation. In addition to compositional and other formal visual elements available in painting and print images, in video animation, narrative elements, action, movement, montage, sound effects, lighting and camerawork greatly increase the capacity for multi-layered sensory experience that engenders contradictions and indeterminacies. This heightens the imaginary and affective engagement of audiences. Unlike the sparse realism used by Holbein, Van Sowerine combines artifice and hyperrealism to produce a work

that is saturated with objects of shared symbolic significance, but at the same time avoids lapsing into the banal. Subtle and indeterminate images of fusion and separation, and the juxtaposition of auditory minimalism against the richness of pictorial elements, underpin the work's deep emotional charge. The juxtaposing of starkly contrasting images is built up through narrative elements and montage. The picture-book setting and imaginary world of innocence and childhood are merged with images of separation and death; the scission between life and death is evoked by the separation of scenes through dissolves and cuts to the pitch black of the empty screen. An extreme economy of sound and absence of dialogue, and the pervasive presence of the corpse in later scenes is counterbalanced by visual adornment, an intensity and richness of colour, backdrops of warm domesticity and above all the persistence of light throughout the narrative sequences. Although *Clara* can be read as a work of melancholia, as a work of mourning that succeeds in overcoming loss, it is also metaphor or allegory of love. The film, which runs

5. Van Sowerine, *Clara*
(2004), film still.

for seven minutes, presents a linear narrative that requires a degree of retelling in order to demonstrate how various filmic and animation devices disrupt narrative flow and referential meaning to produce the work's intensely disturbing – and ultimately its cathartic – impact.

Narrative as the work of mourning

The story of *Clara* is set in a picture-perfect suburban 'house and garden' located opposite a park. Artificial and banal, most of the *mises-en-scène* are those of everyday suburban life. The romanticised white picket fence, manicured flower gardens and brightly wallpapered interiors are conveyed via the sanitised hyperreality often found in mass-produced children's picture-books.

Clara, the protagonist, is represented by an animated child-doll with dark hair tied back in a ponytail. She is dressed in sneakers, corded jeans and a light coloured skivvy, and seems initially to be a stereotypical six- or seven-year-old girl. She is first encountered in a children's playground or park directly in front of the picturesque house. While the physical surroundings appear innocuous, the setting is devoid of human presence and activity other than that of the protagonist. The light is sombre and an eerie silence, briefly punctuated by the faint and distant sound of birdsong, creates a sense of isolation and unease. The 'child' kneels in front of a bed of dark earth strewn with fallen leaves and attempts to pick a dark purple-red lily. As she leans forward to pick the bloom, its petals crawling with black ants, the sinewy and snake-like stem of the flower comes alive and wraps itself around her wrist. In the ensuing tug-of-war, the child falls backward, but has, after all, succeeded in uprooting the bloom. The scene fades to black. In the next scene, the protagonist is pictured sitting on the porch of the house framed by flowers and trees; bright light streams from the windows and the glass frame on the upper part of the front door. Twilight has

given way to night. Clara takes a key from her pocket, unlocks the front door and enters the house. Now her movements are slow and heavy – no longer those of a child.

Through the open door, the viewer's gaze is first directed along a front passage and is then interrupted by a brightly papered wall, indicating another passage going off to the right from which light is emanating. Clara picks up a wooden toy – a pull-along dog on wheels – and runs the wheels back and forth on the polished boards. The silence is broken by the low sound of squeaking wheels on wooden floorboards. With the flower carelessly thrust in a trouser pocket, she passes slowly and mechanically into a second corridor that runs past a kitchen and leads to another room.

The kitchen is bright and clean; typically, there is a fruit bowl, a mug and an empty glass on the table; on the stove there is a large pot of oil boiling vigorously – perhaps forgotten. Clara glances at the boiling oil and then moves forward towards another door – light emanates from beneath it. The camera switches focus to a line of ants that have followed behind her from under the front door. Momentarily, there is the sound of sinister electronic music as her gaze turns towards the light from beneath the door at the end of the corridor.

Clara enters the brightly lit room. On a white-satin-covered table lies an ornate rosewood coffin with brass handles. The interior of the casket is decoratively lined with tessellated white satin, and inside is the body of another 'child-doll' – eyes closed and laid out before burial. The pale, infant-like face is framed by long strands of glistening blonde hair, partly held back by a white satin band. The upper part of the body in the casket is clothed in soft pink, and further along the vertical plane darker lines indicate trousers and black shoes protruding against the white satin wall of the casket. Darker elements of dress enhance the pale vulnerability of the corpse's face. Clara abstractedly runs her hand along the inside of the coffin and places the

flower on the torso of the deceased. She pushes the toy dog towards the face in the coffin as if to induce a response, and then places it in the coffin. The shot dissolves to black.

In the next shot, Clara is pictured staring blankly at the pot of boiling oil; a close-up of her face focuses on bubbles of oil reflected ambiguously, as points light or tears in the protagonist's eyes. She plunges her index finger into the pot of oil, holding it there without registering any feeling. The silence is broken by the rising sound of sizzling flesh as Clara falls unconscious to the floor. The scene cuts to darkness. The next sequence opens with a close-up of Clara's face. As her eyes open, the camera pans to a trail of ants moving across the kitchen floor towards the room where the body is laid out. The sight of the ants provokes an abrupt response and movement towards the room, where the ants, attracted by the flower, have converged on the body in the casket. Now animated and purposeful, Clara snatches the flower from the coffin and throws the wooden toy to the floor. The scene dissolves to darkness as the protagonist gently brushes away the ants from the body and caresses the face of the 'deceased'.

The next sequence returns to the exterior scene of the playground, where Clara is pictured replanting the flower. No longer menacing, it quickly comes alive and is shooting up, anthropomorphically, performing a dance of what seems to be gratitude and joy. Clara becomes aware of what remains of her finger, and the film closes as she sucks the burnt stub.

The doll as ambiguity

Van Sowerine uses dolls in this animation as a powerful device for evoking childhood memories and transporting the viewer into the imaginary realm – which is also the realm of fusion between child and mother. As playthings, dolls help to constitute relationships to the other and therefore permit a working through of social identities. As objects that engender nurturing behaviour, they also collapse the boundaries between child and mother. Kristeva has

shown that the merging of the self with the primary other returns the subject to the realm of the imaginary, where there is a risk of a more radical loss, a loss that she describes as the 'chaotic hyperconnectedness of fusion love'; this state borders on the total loss of self that would ultimately be indistinguishable from a drive towards death. Moreover, while dolls can be iconic representations of the human form, they are nevertheless inert, and as such have traditionally been associated with death and can therefore be viewed as abject. The speechless mask of the doll in Van Sowerine's work operates at multiple levels, as an evocation of the emptiness of melancholia. In *Clara*, narrative, elements of action, movement and gesture constitute the protagonist as an uncanny composite of child and adult. The amalgamation of the two is also realised through contradictions set up between narrative elements and the character's movement, action and gesture. For example, the sequence in which the protagonist has possession of the key to the front door and is shown unlocking and entering the house, together with movements and gestures that are at times purposeful, protective and nurturing are at odds with elements depicting innocence and childhood. The latter include visual details of dress and the careless dangling of the flower from the trouser pocket.

Indeterminacy is intensified in the doubling of the second doll as both love object and corpse, a structuring that situates the work within the dynamics of both love and melancholia. The combination of vision, sound and animation effects result in additional compressions and condensations. Most evident of these is the representation of the flower as an object of both attraction and repulsion – of life and death. Such ambiguities mark the movement between amatory idealisation and the shadow of melancholia that attends the loss of an essential other.

In *Tales of Love*, Kristeva points out that the condition of being in love has the potential to produce extreme psychic disturbance not unlike that which occurs in melancholia. She describes love as a crucible of contradictions, an 'unleashing that

in the absolute can go as far as crime against the loved one'. Alternatively, love is a 'hymn to the total giving to the other... a hymn to the narcissistic power to which I may even sacrifice *it*, sacrifice *myself*' (Kristeva 1987: 1–2). Kristeva's thought provides a framework for reading *Clara* as a work that articulates a movement between melancholia and love. The tendency towards fusion between self and other in states of melancholia and love is reflected in both the indeterminacies and stark contrasts produced by Van Sowerine's use of animation and filmic language. In the climatic scene, the most evident of these is the manipulation of lighting. The boiling oil in which the finger is plunged is reflected as gleaming light – light that first 'doubles' as tears but then pervades the entire screen. Bright light cuts to total darkness as the protagonist loses consciousness; a sensory equivalent of this altered state is transferred to the audience as shock.

The structuring of light and dark articulate the dynamics of love and melancholia described by Kristeva as the 'somber lining of amatory passion'. The act of sacrifice in the climatic scene can be understood as an attempt to fuse with the lost thing, an 'imagined sun, bright and black at the same time' (Kristeva 1989: 13). In *Clara*, this reciprocal dynamic – reflected in the oscillation between separation and connectedness, life and death, childhood and maturity – is maintained throughout the work by the manipulation of sensory devices, visual detail and action. In the interior sequences, domestic or feminine signifiers of care and nurture can be construed either as signs of lack or as metaphorical substitutes for the lost mother. Van Sowerine's corpse is neither abandoned nor fearsome and repugnant; she is lovingly adorned and is finally 'recovered' through the ritual act of the planting of the flower, a signifier of hope and regeneration. This narrative closure counteracts effects produced, for instance, by the confrontation with the corpse and the menacing animation of the flower in earlier scenes, where it is represented as an abject and threatening 'thing'. A sense of unease produced by these elements

is counterbalanced by elements that engender empathy. This is particularly evident in close-up shots that focus on the eyes and faces of the dolls, a structuring of the gaze that leads to idealisation and identification.

Kristeva tells us that the deep sadness of the melancholic subject is indicated by asymbolia. The depressive's speech is 'repetitive, monotonous or empty of meaning, inaudible even for the speaker before he or she sinks into mutism' (Kristeva 1989: 43). Van Sowerine's work is entirely without dialogue, and this absence of the spoken word is intensified by an isolating silence that is broken by the minimal use of sound, which – apart from two instances – is muted and distant. The sense of separation and alienation produced is heightened in the exterior sequences, where streets and park are deserted, conveying a sense of the protagonist's abandonment and vulnerability. In interior scenes, Clara's slow, heavy and mechanical movements are apprehended as visual and synaesthetic equivalents of the melancholic's speech. This capacity to evoke synaesthetic responses reaches its height in the climax of the film with the unexpected and heightened sound of sizzling flesh; the impact is emotionally profound and viscerally intense.

Extreme melancholia results in the disruption of homeostatic processes required for the connection between physical and mental states. In *Black Sun*, Kristeva describes melancholia as 'living death', a condition in which the flesh is felt to be 'wounded, bleeding, cadaverised' (Kristeva 1989: 4). This violence of feeling against the self, the result of an inability to separate from the repugnant thing, drives the melancholic individual towards physical self-harm. The mutilation of the body is an attempt to replace the psychic wound with a real physical wound in order to erase relentless grief and mental suffering. In extreme body art, pain is often viewed as a means of accessing authentic experience, so that the connection between physicality and subjectivity may be renewed. In Van Sowerine's work, this experience is engendered indirectly through narrative, action

and the various elements of sound and vision that transform sense into sensation. Through the semiotisation of narrative meaning and a grafting of affect to the symbolic, her tale of love and loss rises above cliché. This underpins the capacity of the artwork to produce a cathartic resolution.

The next chapter will further explore Kristeva's work on affect and audience response. It will also consider the ways in which the structure of artworks can fail to effect the transference relations required for sublimation to take hold. In such cases abjection is experienced as abjection – as a symptom that blocks catharsis.

Chapter 4

Abjection, art and audience

In previous chapters, we have discussed the way in which creative practice involves a grafting of affect to the symbolic resulting in a rupturing and renewal of discourse and subjectivity. Kristeva points out that, as *practices*, psychoanalysis and art are similar in that they permit an inter-subjective transference of meaning and affect. In creative practice, the transference occurs not between the analysand and analyst, but between the artist and language itself, operating through the double articulation of the symbolic and the semiotic. The heterogeneous language of the artwork, then, becomes a site of inter-subjective exchange with the viewer. The structure of the artwork thus has the capacity to effect a transference of affect that underpins the renewing and cathartic impact of aesthetic experience.

In this chapter I return to the first book of Kristeva's 1980s trilogy *Powers of Horror: An essay on abjection* (1982) and will extend the discussion on abjection in the previous chapter to demonstrate how abjection is implicated in situating and structuring viewer and audience responses to works of art. In particular, I will examine the way in which abjection gives rise to negative affect – fear, loathing and disgust – and how this is played out in the viewing experience. In some cases the extreme otherness of artworks gives rise to abjection as abjection – as a symptom of trauma. I will apply Kristeva's elaboration of abjection to an analysis of works from Australian artist Bill Henson's 1994–5 Venice Biennale series to explore the dynamics of this response

and to illuminate the way in which transference relations in the viewing of art can produce a crisis of subjectivity that fails to be resolved.

In order to establish a framework for the analysis to follow, it is necessary to retrace our steps and to engage more closely with accounts of abjection presented in *Powers of Horror*.

Abjection as the primer of culture

Certain aspects of Kristeva's thought on abjection are particularly pertinent to the interpretation of the works to be considered here. The first is concerned with the way in which codifications of abjection determine femininity and the maternal in patriarchal society. The second aspect, which has already been touched upon, is related to abjection as a process that can collapse meaning, but which is nevertheless fundamental to the constitution of identity and renewal of meaning. Kristeva has shown that this involves a grafting affect to the symbolic, permitting it to register the meaning and value of subjective experience. In *Powers of Horror*, abjection is shown to be co-extensive with fear, the affect that constitutes primary relations between the subject and its objects, and as such gives rise to aesthetic discourse. She suggests that religion and ritual play an important role in the mediation of abjection and the overcoming of unnameable or primal fear. In secular society, art remains one of the few means of mediating abjection. As a spatial concept, abjection refers to processes demarcating the boundaries between the child and the mother's body and between the subject and objects. This aspect of abjection provides a framework for understanding how the viewing subject is situated in relation to artworks, as will be shown in the second part of this chapter.

Abjection is ambiguous from the start, because even as the mother remains a vital support, the imperative to separate that it engenders marks the fearsome beginnings of otherness. Abjection relates both to biological processes and psychic

functioning; it maintains the border between life and death, expelling or jettisoning what threatens life. The corpse is the most abject of all objects, a border from which the body must extricate itself in order to live. Faeces, urine, vomit, pus and blood in an open wound are abjected or expelled from the body to protect it from contagion and death. Food can also become abject when it marks a border between two distinct entities or territories. Kristeva refers to skin on the top of milk as an example. As we saw in the previous chapter, the mother's body is the first object to be abjected, and this process of separation sets down the early demarcations that later give rise to language and the constitution of the ego. Abjection then maintains the boundary between the 'I' and 'not I'; it therefore lies at the limits of representation and meaning. Kristeva draws on religion and anthropology to explain how in religious rites and rituals abjection is codified as a means of separating the sacred and the profane and defining the limits of the individual within social/symbolic order. It this sense, abjection can be viewed as the primer or safeguard of culture.

Abjection assumes different codings from culture to culture and according to various symbolic systems. Some of its variants include: defilement, food, taboo and sin, all of which turn on the prohibition of certain behaviours. The underlying principle of rites and rituals that determine the sacred and that separate the clean from the unclean is the prohibition of incest. In Christian iconography and ritual, for example, the image of the wounded God, and rites of communion, mediate death through the prospect of transcendence. The mediation of death is also a mediation of the deepest fear – horror of the unrepresentable, or that which cannot be seen – which, through Kristeva's concept of abjection, can ultimately be understood as the pre-symbolic or archaic mother. In pyschoanalytical discourse, fear of the un-representable is linked to the fear of castration invoked by the sight of the mother's genitals – in art, often represented as a cut, a wound or decapitation. Fear of the phallic mother (life-giving

and life-threatening) is the underlying symptom that has given rise to images of female monsters in mythology and to various images of the monstrous feminine in art and popular culture (Creed 1986). One of the most horrible of these is the Medusa's head, mouth agape and writhing with serpents – a representation which Freud suggests takes the place of representation of the female genitals. In his 1927 essay 'Fetishism,' he observes, 'Probably no male human being is spared the terrifying shock of threatened castration at the sight of the female genitals' (Freud 1981: 354).

Kristeva's conception of abjection takes us beyond the ideas of Freud and Lacan that posit woman as lack and as castration. She notes that various religious discourses and rituals that make up the sacred are, more precisely, attempts at coding the taboo against incest in order to maintain the separation between the sexes. This has also meant giving men rights over women. Women are nevertheless feared as baleful schemers possessed of wily and magical powers. Underlying religious and ritual codifications of abjection in patriarchal societies is the casting of the feminine as a radical evil that needs to be repressed (Kristeva 1982: 7). On the other hand, the feminine is also feared as a powerful 'other'. Rituals of defilement also indicate the social and symbolic importance of women, and in particular the mother. Kristeva looks at two types of defilement to explain this. The first is related to menstrual blood, which represents danger from within the social aggregate. Fear of pollution from menstrual blood is also a fear of the reproductive power of women and a reminder to men of their own mortality. The second is related to excrement, decay, disease, infection and the corpse, which present as external dangers. Because the mother presides over the care and training of the infant at a time prior to language, her handling of the child's bodily functions operate through a binary logic that articulates prohibitions related to maintaining the clean and proper body. This constitutes what Kristeva calls a primal or semiotic mapping of the body that precedes, and is a precondition

of the child's entry into the symbolic. Though it does not bel
to the symbolic order, this mapping is indicative of mater
authority that is later repressed by paternal laws, but nevertheless
continues to exert a psychic influence. Ritual can thus be
construed as a means of absorbing and neutralising the psychic
connection to the mother and to partial 'objects' or pre-objects
that are constituted in the early mother–child relationship. Rituals
and rites of defilement are acts that have a trans-linguistic
impact, and as such they are inscriptions of limits, 'spoors of the
most archaic boundaries of the self's clean and proper body. In
that sense if it is a jettisoned object, it is so from the mother'
(Kristeva 1982: 73).

Rites and rituals of defilement thus operate as a process of
abreaction, through which conflicting drives or semiotic energy
related to the archaic mother are displaced through a system of
ritual exclusions that also inscribe limits placed on the feminine
and on maternal authority. Through her account of rites and
rituals, Kristeva demonstrates the way in which the act of
excluding abject things constitutes collective existence, identity
and the limits of the individual in relation to society. It also
illuminates how the feminine has come to be associated with the
abject and the monstrous in patriarchal societies.

Prohibition turns on issues of fear, pleasure and pain. The
paternal law, which establishes a separation from objects that
are forbidden, dangerous and unclean, is also concerned with
the primary object of pleasure and desire, ultimately desire for
the mother and the pain of separation. Kristeva suggests that
abjection is an indication of an incomplete separation from the
mother and is also a process that instigates primal repression.
Her account of abjection goes beyond a concern for the socialising
impetus of abjection to an examination of the way in which, as a
psychic process, it brings about alterations within subjectivity
and extends symbolic competence. Her departure in this direction
starts with an emphasis on the fragility of the law and its

prohibitions as an effect of the beckoning force of the archaic mother. She argues that confrontation with the feminine is not a confrontation with a primeval essence, but with an unnameable other that can engender both fear and *jouissance*. It is this ambiguity that is the basis for creative production in literature and art and that structures the audience's affective responses.

Why fear?

'The abject has only one quality of the object – that of being opposed to *I*' (Kristeva 1982: 1). It simultaneously beseeches and pulverises the subject. All abjection is a recognition of want for the maternal body on which being, meaning, language and desire are founded. Because want is preliminary to being and object, the child has a sense of the abject even before things *are*, and drives them out even before they are signifiable. What is abjected in this first separation is the biological body of the mother as a means of staying the death-drive, a drive predicated on the tendency for matter or life to return to a state in which everything is the same. Abjection takes hold when there is a failure of the capacity to identify with something outside that would constitute the subject as a separated entity. Kristeva describes the subject beset by abjection as the child who has swallowed up his parents and is therefore frightened by the act and by finding himself 'beside himself alone'. Brushing up against the unnameable thing collapses meaning – it must therefore be excluded because it threatens the emergence of self.

However, abjection is an ambiguous border, because even while releasing hold on the subject's entry into language, it does not radically cut the subject off from what threatens it, but rather demarcates a space from which signs and objects arise. In this sense, abjection is an indication of our being alive in the world – a physiological and psychic functioning or responsiveness that allows us to make sense of our encounter/enfoldment in and with the world. As was shown in the previous chapter, abjection is a

precondition of narcissism. It is co-existent with narcissism and is what 'causes it to be permanently brittle' (Kristeva 1982: 13). This brittleness is an indication of the instability of the symbolic function, constantly threatened by a crucible of conflicting drives – related to attraction and repulsion of the archaic mother – which Kristeva designates the chora. It is here that life-drives and death-drives undergo cathexes or investments required to correlate a 'not yet' ego with an object, 'in order to establish both of them' (Kristeva 1982: 14). This dichotomous and repetitive process of the chora that constitutes inside/outside and ego/not-ego borders, exerts both centripetal and centrifugal forces that aim at settling the ego at the centre of a system of objects. Those that are centripetal exert a movement inward, threatening a collapse between objects and centre; those that are centrifugal precipitate and outward motion – and when they fasten on to the other, come into being as a sign or meaning separating the ego from the object. Abjection falls away once meaning takes hold. It is experienced only if the other has settled in place instead of what will be 'me', 'Not at all an other with whom I identify and incorporate, but an other who precedes and possesses me' (Kristeva 1982: 13). Abjection is experienced as fear and loathing when rational meaning fails to emerge. In psychoanalysis, this 'possession' refers to borderline states in patients who suffer phobia. In these cases the abject or fearsome object is only partially excluded. Although there is an insufficient differentiation between subject and object, the contents of the psyche are made evident in the speech and behaviour of the patients without being integrated into judging consciousness. This produces discourse that, unlike rational communication and scientific discourse, is aesthetic or mystical.

In her account of phobia, Kristeva makes a clear distinction between fear that is communicable through language and fear as a pre-symbolic affect that emerges through abjection on its way to constituting the ego and objects. Communicable fear is a

product of earlier archaic signals that have already been transformed into signs, and therefore belongs to external reality. Abjection points to a dynamics of fear prior to the emergence of the object and upon which the very capacity to symbolise external reality is dependent. Fear and the object are associated from the start because the first object of experience is that of the archaic mother. Something akin to fear is first experienced in the trauma of birth, a violent break that upsets bio-drive balance. The constitution of object-relations is a reiteration of the unsettling of this fragile balance. 'Fear and the object proceed together until the one represses the other' (Kristeva 1982: 34). This raises questions about the nature of objects that emerge within the psychic space as opposed to the forms of repression that permit objects to emerge as signs. In Lacanian psychoanalysis, the mother as first object is both desiring and signifiable. The object that emerges as a sign is one that has been introjected as a mental image that correlates with an external other. Kristeva's conception of abjection indicates that a class of objects exists prior to language: the need for food, air and comfort, which in early life are related to the mother. Absence of the mother, frustration or denial of these needs produces aggressivity, the violence of rejection and death-drive. The phobic object, or object of fear, appears at the place of a non-objectival drive, which, unlike the sexual or erotic drive that is directed towards others, is instead directed inward, towards self-preservation. The phobic object is therefore not an object of desire, but an object related to want and to primary processes. What, then, is the relationship between phobia and art? Kristeva tells us that the language of art is the language of want, and explains how this is so through her extended account of phobia. She draws on Freud's account of Little Hans's phobia or fear of horses to describe phobia as 'an abortive metaphor of want' (Kristeva 1982: 35).

Phobia is an indication of the frailty of the subject's signifying system and the instability of the object relation. Unable to produce

metaphors by means of signs, the phobic subject produces them within the materiality of drives. Phobic hallucinations are an indication of an avoidance of choosing between an object of want and an object of desire. What emerges from this process is *affect* projected as internal images – hallucinations that are partial objects since they point to an object that remains unnameable. Lacking any external or objective correlative, these hallucinations articulate a void that lies beyond the emerging play of signifiers. 'Such a void and the arbitrariness of that play are the truest equivalents of fear' (Kristeva 1982: 37). The arbitrariness of the phobic metaphor is illustrated in the account of how efforts to rid Hans of his fear of horses results in a transformation of his phobia into a loathing for raspberry syrup – the colour of which evokes the edge of a gash (Kristeva 1982: 35). The phobic metaphor is a metaphor that has mistaken its place and as such does not belong to verbal rhetoric; it is a 'fetishistic' and temporary preserver of life. In childhood, phobic drive produces symbolic activity, but not the object; in adults it produces a discourse devoid of meaning and the abjection of self. Hence the metaphors produced are not metaphors in the true sense but are an index of some non-thing or unknowable object, a hallucination of nothing (Kristeva 1982: 42). In such cases the phobic drive cathects symbolic activity itself. This activity can be understood as a play of internal images that belong to the pre-preconscious and unconscious realm, and in this sense, are similar to dream images. Phobic images do not correlate drive to any external object, however they do prevent a total collapse of the subject.

Kristeva notes that all language is 'fetishistic' in that it separates the subject from objects and is a substitute for objects, the first of which is the abject, the primary thing or m/other. The phobic hallucination or metaphor emerges at an intermediary moment in the process that moves from primary narcissism to secondary identification. Phobia, or fear, returns the subject close to the place of the mother; affect erupts and is projected by means

of images that belong to psychical rather than external reality. The hallucinatory metaphor of fear is produced by a visual cathexis; it is a sign (of want), of the absent mother manifested as internal visual images that frighten, but also fascinate, the subject. This fascination leads to voyeurism, which, as Kristeva observes, is a side-effect of phobia. In childhood, phobic drive produces symbolic activity, but not the object; in adults it produces a discourse devoid of meaning and the abjection of self.

Displacements and condensations that make up the phobic metaphor are unfathomable to psychoanalysis; only art can linger over abjection, and thus succeed in overcoming fear. Kristeva describes the writer or artist as 'a phobic who succeeds in metaphorising in order to keep from being frightened to death; instead he comes to life again in signs' (Kristeva 1982: 38). The artist immersed in the language of want is aware of the dangers presented by pseudo-objects, but is compelled to take the risk. This is so because straying towards abjection is not only aligned with fear, but also with the fascination and *jouissance* of moving towards the other and infinitude.

Abjection and space

As a process that determines borders between inside and outside, abjection can also be understood as a spatial concept. In-between, composite and ambiguous, abjection is that which does not respect borders, positions and rules. The place of the abject is the place of the splitting of the ego. The abject implies an ego that repeatedly places, separates and situates itself and 'therefore *strays* instead of getting his bearings, desiring, belonging or refusing...instead of sounding himself as to his "being", he does so concerning his place: "Where am I?" instead of "Who am I?"' (Kristeva 1982: 8). To be abject is to be an exile or deject possessed by a non-object. As self-appointed exile and deject, the artist strays towards abjection and becomes a deviser of territories, languages and works.

Abjection is a demarcation before that which emerges in the *gestalt* of Lacan's mirror phase; it posits a conception of space and locality that is ambiguous – somewhere between subject and object, perception and consciousness. It is a space not of external reality, but of psychic reality, where different objects may occupy the same space at the same time as in condensation in dreams, where subject and object may collapse into each other. Psychic reality refers not to real objects but to hallucinations or fantasies. In terms of a viewing relation, this results in a collapse of the demarcation between the viewing subject and the 'object' of the gaze. Victor Burgin refers to Freud's paper on the theatre of desire, 'A child is being beaten' to illuminate further how this embodied and desiring mental space constitutes a subject that can be positioned in the audience *and* on the stage, simultaneously occupying the role of both the aggressor and victim (Burgin 1990: 111). Maurice Merleau-Ponty's description of the reciprocal relationship between the seer and what is seen further elucidates the ambiguous relationship between subject and object through the notion of 'chiasm' – an enfoldment or intertwining of the seer and what is seen, 'so that the seer and the visible reciprocate one another and we no longer know which sees and which is seen' (Merleau Ponty quoted Burgin in 1990: 113). In the reception of artworks, this relation allows the viewer/audience to empathise or share in the experience of what is being presented. However, as will be seen in the discussion of the work of Bill Henson, in cases where abjection appears *as abjection*, it can block empathy and identification with what is being shown or represented.

Abjection and perversion

The abject is related to perversion, as is indicated by a desire to look even when one is repelled or afraid. Abjection is related to the superego and can soften or hold sway over it because the subject of abjection neither refuses to give up, nor to uphold prohibition and law, but instead turns them aside misleads,

corrupts and misuses them. Evidence of this can be found in the tendency to defuse fear through humour and parody. The superego is not the same as *conscience*, since it is made up of injunctions and inhibitions established in pre-oedipal or pre-linguistic stages of development as well as those that result from mature reflection and self-awareness. 'To each ego its object, to each superego its abject' (Kristeva 1982: 2). Because it is a composite of conscious and unconscious elements, the superego constitutes ambiguous and fluid relations between the subject and the system of social laws, and it is this dimension of abjection that is mediated in artistic practice, which involves an ability to project oneself into the abject, to introject its logic, and as a consequence to pervert language through style and content.

A mastery of language and rhetorical codes allows the artist to negotiate the risky borders of abjection while maintaining a hold on identity. Where identity fails and the subject does not emerge, abjection presents as a void returning the subject to the original site of separation and trauma – to fear and loathing. As a *physiological* symptom, abjection serves as a protection from contamination and death, but it is also an indication of crime and treachery, cunning, murder and hypocritical revenge. Abjection is 'immoral, sinister, scheming, and shady: a terror that dissembles, a hatred that smiles, a passion that uses the body for barter, instead of inflaming it, a debtor who sells you up, a friend who stabs you...' (Kristeva 1982: 4). This is the secret horror that abjection reveals.

Abjection, *jouissance* and the sublime

As the in-between and the ambiguous, abjection also gives rise to the *jouissance* of oblivion and pleasure of transgressing the law. 'The time of abjection is double: a time of oblivion and thunder, of veiled infinity and the moment when revelation bursts forth' (Kristeva 1982: 9). Abjection is an ambiguous border, an index of the unnameable lining the sublime. Through practice, sublimation offers the possibility of naming the pre-nominal.

How does sublimation take hold? We have seen how abjection as primal repression occurs prior to the emergence of the ego and its objects of representation. It is a structure within the body that occurs at the limits of the unconscious and prior to it; as a symptom or physiological response, it is what the body must give up in order for sublimation to occur. Sublimation is the process by which thing presentations, drives, sensations and affects are transformed into word presentations. This occurs because the subject of abjection is also an already constituted (heterogeneous) subject of the symbolic. The abject is the most fragile and archaic sublimation of an object that occurs prior to the emergence of the object and language. The affect of fear produced by the abject shapes a 'logic' that constitutes the unconscious – a confusion of pseudo-objects and the non-sense of the imaginary realm where drives connecting with maternal elements give rise to secondary identifications. Although the sublime moment borders on the realm of the intolerable significance of abjection, through sublimation, abjection is controlled. There is a displacement of drive and affect towards the sublime object, which dissolves into bottomless memory of imaginary maternal bonding. This identification triggers perceptions that produce the sublime metaphor; it is both a bonding with and a partial substitute for the lost ('good') mother. It is in this sense that the abject is lined with the sublime. 'It is not the same moment on the journey, but the same subject and speech bring them into being' (Kristeva 1982: 11). For Kristeva the abject subject is *par excellence* the artist. Does the subject, as the viewer of art, necessarily follow the same path that the artist has taken? The second part of this chapter will explore some of the issues that Kristeva's theorisation of abjection has for the audience or viewer of art.

Abjection, art and audience

Kristeva has demonstrated how abjection operates as a process that is necessary for the development of the ego and identity. It

brings about the psychic differentiation preceding the separation of the child from the mother's body; it is therefore also an articulation of the inside/outside borders of the subject. As a symptom, abjection appears as affect – fear, loathing and aggressivity directed towards an unnameable other. Artistic practice is able to harness and mediate these impulses by translating them into aesthetic form. Kristeva's account of abjection focuses on the artist as subject, and on practice itself as a means of remaking and renewing the subject. However, in her analysis of the literary works of Louis-Ferdinand Céline, she observes that art does not always succeed in protecting against the abject as non-differentiated otherness. In such instances, it can result in the projection of drives onto an object of hatred in the subject's external reality. This results in representations that reflect fear and loathing of this (social) other in Céline's work, the Jew and the woman. The following analysis of Bill Henson's work examines what kind of viewing relations are available to the viewer who occupies the place of this abjected other.

Bill Henson

The reception of artworks does not occur in a vacuum, but is embedded in various discourses that frame audience responses. This was dramatically demonstrated by the events that followed the publication of Salman Rushdie's *Satanic Verses* in 1989. The 'Rushdie affair', spanning almost a decade, is testimony to the capacity of art to galvanise religious fervour and political antagonisms. The publication not only forced the author into protective hiding for many years, but also sparked civil unrest and an international crisis between Britain and the Muslim world. To a lesser degree, the power of art to provoke controversy is also indicated by intermittent demands for censorship of certain artworks, for example those directed at the works of Robert Mapplethorpe and Andres Serrano in the 1980s and 1990s. In the case of the former, debates turned on the issue of pornography

and in that of the latter – and in particular the 1990 work *Pis Christ* – the debates were mainly related to blasphemy.

The vexed issue of censorship has again been raised in relation to recent exhibitions of the work of Bill Henson, which have polarised public opinion in Australia. Often such debates result in renewed protests against what is perceived as a threat to intellectual freedom and the autonomy of art. This raises the question of whether it is possible to move beyond the circularity of such discourses and arrive at an engagement with art that remains critically generative, but at the same time engenders more inclusive and ethical relations. Although Kristeva puts forward a view of art as ethical practice, she does not provide us with any clear answers to this question. However, her work on abjection does provide a scaffold for reflecting on the complex dynamics at work in the reception of controversial artworks, and gives us some insight into the emotions that are provoked by these.

Whose vision? Whose catharsis?

Where art operates at the service of repressive ideologies and is supported by institutionalised discourse, interpretation as transgressive practice becomes a new imperative. Images are *representations*, and as such they are producers of ideology even as they evoke pleasure and permit us to articulate both conscious and unconscious or repressed desires. The question of who derives power and pleasure from images is not only confined to the site of production, but also to that of consumption – to issues of address and reception. Address relates to how images construct the subject as an idealised viewer who produces 'preferred' readings, whereas reception refers to a potential or 'real' viewer who may resist the interpellative power of the image because of a failure to identify with its representations. In many instances, institutionalised discourses – gallery catalogues, reviews and other commentaries – operate as additional devices through which preferred readings and audience positionalities are structured

and endorsed. Hence critical discourses as well as the context of viewing produce differential power relations between the addressor and addressee. This has certainly been the case in relation to the works of Bill Henson that represented Australia in the Venice Biennale of 1995.

The psychoanalytical concept of art as cathartic resolution of forbidden wishes and desires begs the questions: whose visuality? Whose catharsis? Hal Foster (2008) observes that contemporary art practice is fascinated with trauma and abjection. As a site of affect, abjection provides a radical alternative to the repressive regimes of the symbolic. The violated body is 'often the evidentiary basis of important witnessings to truth, of necessary testimonials to power' (Foster 2008). Foster observes that this positioning of truth carries the danger of restricting our political imagination to two camps, abjector and abjected; in this context, choosing to be a phobic object of the abjector remains the only way to avoid being misogynist or racist. Foster's comment reveals the power of art to structure and delimit subject positions available to audiences, while at the same time deflecting attention away from the original site from which power has been deployed. Art constitutes looking not as vision, but as visuality. The latter is defined by Nato Thompson as a discursive field of power, where 'visual sign systems are deployed to achieve certain ends' (Thompson 2004: 39). This raises the question of whether the fascination with abjection is a nihilistic refusal of power or an assumption of power in a different guise.

Obsession with images of death and the corpse is also an obsession with the unrepresentable. The primacy of the (visible) male organ that links seeing, knowing and power in Western culture constitutes woman as lack. Cecilia Sjöholm observes that in a culture dominated by the fantasy of phallic monism, the limits of visibility are doubly determined, 'on the one hand by a veil covering that there is nothing to be seen, while on the other by a fantasy of a castrating violence beyond that veil' (Sjöholm

2005: 121). This fear of castrating (maternal) violence is repressed in the idealisation of the female corpse in art and literature, and in images of decapitation and dismemberment. Artistic practice is a vehicle for the sublimation of instinctual drives, a process that results in a cathartic resolution. However, while the artwork presents the socialised face of abjection, it also masks an unconscious fantasy of phallic power, which elevates seeing as knowing and is based on the primacy of the male organ.

The question of who derives pleasure and power from images of death and violence is often overlooked in discourses that seek to valorise works of art. As Michel Foucault has observed, power can be viewed as the way in which certain actions modify others. Power seduces, it makes easier or more difficult; in the extreme it constrains or forbids absolutely (Foucault 1981: 789). The ultimate deployment of power, physical force or violence, has largely been superseded by disciplinary discourses and the way in which they are structured through mythologies and other institutional practices. This can be demonstrated in certain commentaries that surround Henson's work.

Edward Scheer (1998: 29), combines his review of Henson's untitled 1991–5 photographs with an analysis of violence in Rowan Wood's film *The Boys*. In his review, Scheer's acknowledgement of violence in these works is juxtaposed with reference to Hannah Arendt's observation that violence appears when power is in jeopardy. In Scheer's analysis, the textual shift from notions of violence as an attempt to regain power to one of violence as a means of recuperating masculine identity is partially achieved through an appropriation out of context of material from elsewhere – that is to say, the gaining of Arendt's complicity, an appeal to authority that confers power to the addressor. A deft movement in the commentary, from Wood's film to Henson's photographic works, completes the textual transcription by which violence discursively achieves the status of the sublime through its un-representability: 'They [Henson's photographic works]

offer a perspective on violent death as that which cannot be represented' (Scheer 1998: 29). Scheer's use of 'we' in commenting on what cannot be said of Henson's images presumes a common perspective and a shared response with respect to the works he discusses. However, for some viewers of Henson's images, the experience turns on the abject rather than the sublime. This is so because vision as raw perception and as physiological process takes over from visuality.

The context of the gallery, the technical processes involved in making images and the discourses that surround images constitute a scopic regime or a field in which certain forms of power operate to produce prescribed modes of seeing, while negating other modes of perception. Critical commentary on Henson's work posits death and trauma in their already dematerialised and sublimated forms; because abjection has been mediated, death and trauma are not part of experience, except in an abstract sense. Theoretical abstraction detracts from acknowledging that affect and sensation evoked in the viewing of images are tied to real bodies and particular memories and histories. This blind-spot of theoretical abstraction can be seen to operate in primarily formalist and art-historical discourses surrounding Henson's works. Such discourses have had a tendency to negate alternative interpretations – the framing or reframing of images through a 'retelling' by a specific material viewer. Such a retelling produces situated meanings that emerge at the point of reception. It is a mode of interpretation that is concerned not only with the question of the subject who has already 'spoken', but also with the differential and particular meanings, affects and sensations produced by the subject who 'hears' and is impelled to respond.

Henson's works from the series named *Untitled* that represented Australia at the Venice Biennale in 1995 consist of over a dozen massive photographic images (most of them 200.1 by 244.5 cm) depicting a twilight forest scene of abandoned cars.

Gamin-like, naked figures inhabit the twilight landscape: two deathly figures entwine ambiguously in acts of violence or sex; a female figure is dragged naked by the hair; another lies, legs akimbo, with what appears to be blood splattered between her thighs, her neck in an unnaturally twisted position suggestive of violent death. However, the contextualisation of these images in the rarefied locations of major galleries acts immediately to constrain and shape what can be said about them. Brian O'Doherty (1986) has described the phenomenon of the gallery as 'white cube'. The gallery is a white, ideal space which subtracts from the artwork any cues that interfere with the fact that it is 'art' and separates the work from anything that would detract from the work's own evaluation of itself. The gallery exudes the sanctity of the church and the formality of the courtroom, tending to construct the spectator as a disembodied eye, a faculty that relates exclusively to formal visual means and is immersed only in those ideas surrounding the work that have been circulated via critical discourses sanctioned by the institution. 'It censors out the world of social variation, promoting a sense of the sole reality of its own point of view, and, consequently its endurance or eternal rightness' (McEvilley 1986: 9). Let us look at some of the comments that have constructed such a point of view with regard to Henson's work.

Isobel Crombie, in the gallery brochure, comments:

Bill Henson beguiles his audience with images that of a confronting, but strangely beautiful world...His photographs are curiously non-intrusive...Henson's figures remain both anonymous and essentially inviolate, apparently acting according to their own desires and needs...The ritualistic appearance of their activities is not violent; there is a sensual slowness to what is happening that makes it more like a dream experience...(Crombie 1996: 9)

If the reader is confronted with a conception of death as the ultimate dream experience, a question that arises is, 'Who is doing the dreaming and to what realities might the dreamer(s) awake?'

Henson has commented in a television documentary on his work that, inasmuch as the figures remain apart from any specific identity, they belong to a dream or fantasy world and remain essentially inviolate. The separation of these works from lived reality is achieved through distancing discourses that negate the manifest visual rhetoric of the works. His collage technique of tearing the paper has been described as the trace of the artist's labour, 'marking the force of the unrepresentable' (Scheer 1998: 29), or as a formal element of composition, 'punctuation points dividing the planes of the pictures' (Crombie 1996: 13). In the Biennale Catalogue (1995), Crombie devotes a great deal of space to the discussion of technique and formal elements in the works, to Henson's careful eye for composition, which, she suggests, produces a 'satisfying unity between the various components of the overall work (Crombie 1995: 13). Then there is mention of classical and romantic allusions, which combine to produce a sense of 'otherworldly creatures' (Crombie 1995: 14). Landscape and figures have similarly been read with reference to a long line of Renaissance and post-Renaissance 'masters'. If there is any story in such accounts, it is that of the artist's heroic progress through the history of art. Taken to its logical conclusion, Crombie's focus on formal elements reduces realistic representations of the human form to patches of colour or the abstracted *chiaroscuro* effects of shadow and light. The body in this context is transformed into, or becomes continuous with, the landscape that surrounds it, a *terra nullius* to be mastered and emptied of any landmarks that may distinguish it in terms of a specific time and place or of an historical identity prior to its incorporation in the artist's vision. And yet there are those who feel assaulted by these images. Indeed my own initial engagement with them evoked a violent nausea. It would seem that these works are affective and affecting in ways that go beyond what is made available in the critical accounts discussed, and what lies beneath the intentional structuring of the work in relation to prior artistic practices.

Susan Sontag (1977) observes that the sanctity of photographs is derived from a continuing sense that they are indexes of the people they represent. This is evidenced in the way in which there is a reluctance to discard or destroy them. If one applies the formalist approach to the catalogue image (No 12) in which the tearing or cutting of the paper extends from the figure's pelvic bone and across the pubic region, the sense of sexual violation and amputation realised through the precise positioning of the cut or tear are rendered inadmissible. And yet as an indexical sign, the tear in the paper is not the indication of an unrepresentable force, but is causally linked to the *act* of tearing – of 'wounding'. Moreover, the rhetoric of the image is insistent in its articulation of violence – highlighting the blind-spot of Crombie's formalist interpretation and its refusal to admit that the reading of images is seldom free of experiential contexts. The violence of the image instantiated by the indexicality of the tear/wound evokes abjection, returning the viewer to the realm of the body, to vision rather than to visuality. When this occurs, sublimation is bypassed, abjection prevails, and there is a collapse of meaning – which is also a refusal of meaning. This may well account for the revulsion felt by some viewers of Henson's work.

Let me turn now from the content of the images to the curatorial process involved in the staging of this exhibition in 1997 at the Lawrence Wilson Gallery in Perth, where I first encountered Henson's works. Entry to the exhibition was through a black-curtained entry similar to that found at the entrance of a peep-show or cinema auditorium. Inside the gallery it is dark. The only available light appears to be emitted by the works themselves, drawing the viewer closer in order to decipher the images, and then directing the viewer around the walls from image to image. The viewing trajectory is predetermined by a narrow corridor winding past the images (something like a carnival ghost-train) that also prevents viewers from retracing their steps. The need to accustom one's eyes to the darkness means

that the viewer must come very close to the images before being able to make out any detail. The viewing space of the exhibition, like that of the cinema, produces an illusion of what Laura Mulvey has described as voyeuristic separation (Mulvey 1981: 208). In such a space, darkness separates the audience from the screen and from other viewers, producing a sense of self-contained voyeuristic pleasure. Paradoxically, there is a temporary loss of ego in the fantasy of the film, and *at the same time*, a construction of ego ideals via identification. This identification involves the ego's desire to fantasise itself in a certain active manner – sometimes involving cross-gendered identification – or else it may involve the desire to be desired. However, while Henson's staging of the exhibition promises the fantasy of cinematic experience, compositional structuring of the images, and their *mises-en-scène*, prevent identificatory processes from taking hold.

In true Proppian[1] fashion, the female forms in Henson's untitled works are passive, being done to, having been done to; the male forms are active, doing, moving in the frame, and from frame to frame, finding something else to do, someone else to do it to. The male figures are presented as active, and therefore as the perpetrators of acts, while female figures are passive and therefore cast as victims of violent acts. We have now come full circle, to Foster's observation that images of violence and death hold the danger of limiting the choices of identification available to the viewer. In the case of the Henson images, the dynamics of identification turn on identification with the image victim/corpse or that of the perpetrator of violent acts. Mulvey draws on Lacan's theory of mirroring to argue for two basic responses in the viewing of images: identification and objectification. In the case of identification the general tendency is towards same-sex identification. Objectification, which involves the taking of voyeuristic pleasure by looking without being seen has been shown by John Berger to be predicated on the male gaze. For the female viewer of Henson's images, viewing is

therefore confined either to identifying with the corpse or to taking masochistic pleasure from the sight of the corpse. This double articulation of the viewing dynamic goes some way to explaining why it is predominantly women who experience abjection in response to these works. Kristeva has shown that a failure of identification results in the experience of abjection as *symptom*.

The notion of abjection as a spatial concept is also pertinent to understanding the dynamics of audience response to Henson's works. As we have seen, abjection operates primarily through ambiguity. The staging of the exhibition draws the viewer into a space of indeterminacy, intensified by the darkness of the gallery and the backdrops of the images from which the figures emerge. The forest in twilight is reminiscent of scenes in the movie *Mad Max*, and reports of grisly acts of murder in the Nangarra forest on the outskirts of Perth; but the catalogue insists that these images have no connection with any reality. This permits the work to operate through the illusion of what Donna Haraway once described as the 'god trick' – the presentation of a view from nowhere or from everywhere – which in either case amounts to claims of possessing 'the power to see and not be seen, to represent while escaping representation' (Haraway 1991: 188). Kristeva has shown us that abjection is a state in which the subject is unable to establish his or her bearings and where the concern is not with 'Who am I?', but 'Where am I?' Henson's setting up of the exhibition invites complicity by evoking a sense of separation of the works from lived reality. It should be noted that no signs or public notices were posted to inform audiences of the nature of the exhibition. For some viewers this resulted in the sense of being mislead or drawn into unwilling complicity. Here, abjection is manifested as affect – the anger and disgust that comes from a sense of being corrupted or betrayed. In some viewers, more extreme physiological symptoms of abjection indicate a much deeper psychic disturbance.

In her work *Banished Knowledge* (1990: 55), Alice Miller explains how Freud's theory of infantile sexuality recast patients' reports on sexual abuse as sheer fantasies attributable to their instinctual wishes. This view, still entrenched in various discourses on childhood trauma and abuse, is an example of the way in which individual experience is invalidated. Is it possible (beyond hysteria) to draw some connection between Freudian discourse and the discourse of the white cube as it is revealed through the staging of Henson's exhibition and its valorisation in critical commentaries? How might audiences not trained in art theory and history view them, and on what basis might such viewers articulate an alternative reading?

In her book *Empathic Vision* (2005), Jill Bennett argues against Geoffrey Hartman's view that images of violence have the capacity to engender secondary trauma. She suggests that the notion of images returning viewers directly to the scene of trauma are inadmissible in films and artworks, since artistic images are not representations of real events. Hence, according to Bennett, the shock engendered by graphic images is registered by a 'third party', or 'disinterested viewer'. This is the shock of art that leads to critical thought rather than 'crude empathy' (Bennett 2005: 8–10). However, aesthetic experience involves heterogeneous contradiction, and puts the subject into process; affective responses result not in a sense of separation, but in dissolution of self; self and other become co-extensive, and this is the basis for identification. When identification occurs, there is a return to the ego and to language. Kristeva has shown how the process of abjection allows the sign to be continually remade at the borderline of the psyche and the outside world via sublimation. However, she also explains that the image is determined by *whose image it is*, that is *for whom it signifies*. For some viewers of artworks that shock, sublimation fails to take hold, and abjection is experienced as *abjection*. This results in an inability to access the language and distance required for identification

to take place, or for critical thought to take hold. That this can and does occur in some encounters with images indicates that there is no 'third party' – the viewer is returned to the 'other' *as self* – to the space of *primary* trauma or abjection. Such an understanding of the dynamics of viewing does not imply the need for censorship of art, but for a more nuanced understanding of the dynamics of censorship itself – particularly as it relates to debates and discourses surrounding trauma, abuse and the potential uses and abuses of images in art and the media.

Chapter 5

Research as practice: a performative paradigm

In Chapter 1, I discussed Kristeva's concept of revolution and creativity as an aspect of the transgression of prohibition made possible through biological and material processes. This is related to what Kristeva has theorised as the semiotic disposition of language that constitutes subjectivity. In Chapter 2, I applied these aspects of Kristeva's thinking to argue that practices of interpretation, like those of making art, also have the potential to be creative and revolutionary. In her earlier works, *Desire in Language* (1980), *Revolution in Poetic Language* (1984) and in her short essay 'The system and the speaking subject' (1986a), there is an emphasis on revolution as the transgression of prohibition related to a time in history when capitalist and other repressive ideologies and their truth-claims dominated. The social and political landscape of the times therefore presented clearly definable targets for avant-garde critique. In her earlier works, Kristeva focused mainly on textual practice and writing as transgression. However, it has become clear that her ideas can be applied equally to other forms of practice.

In her later work *The Sense and Non-sense of Revolt*, first published in English in 2000, Kristeva examines the question of what figures or forms revolt can take in the 'power vacuum' of contemporary society, where truth has been relativised and the effects of politics and discourse are both normalising and falsifiable. This new world order is neither totalitarianism, nor is it fascism, but works through abstracted and diffuse disciplinary

regimes exerting 'indirect and redirectible repression' (Kristeva 2000: 5). In a secular world where revolt is no longer encoded in religious ritual, and where social bonds are mediated by consumerist culture and its accomplice, the media-driven spectacle, Kristeva asks whether it is possible to recapture the spirit of great moments of twentieth-century revolt – and indeed if there is even a necessity for a culture of revolt in the context of a society of readymade gratification and entertainment, 'the culture of the show'. She answers this question by observing that if society is to avoid stagnation and barbarism, revolt *is* necessary, and can be developed through an engagement with, and an extension of our aesthetic heritage.

In her later work, Kristeva points out that the idea of prohibition and transgression, though still possible in certain contexts, must now give way to new figures of revolt and an extension of what we understand as experience. The heart of a new culture of revolt can be found in the realms of art and literature, understood as experience, 'which includes the pleasure principle as well as the rebirth of meaning for the other, which can only be understood in view of the experience of revolt' (Kristeva 2000: 8). This requires going beyond the text to a clarification of the subjective and historical experiences of the artist. It should be noted here that Kristeva's use of the term 'historical' draws on Freudian psychoanalysis and its focus on how the relationship between individual (private) histories and experiences and institutional discourses and historical narratives are played out in subjectivisation. She notes that our cultural history and tradition has produced different forms of artistic experience and subjectivity. This subjectivity is 'coextensive to time – an individual's time, history's time, being's time – more clearly and more explicitly than anywhere else' (Kristeva 2000: 8). In her elaboration of new 'figures of revolt', the artist's subjective history and experience also encompasses the artist's aesthetic experience and subjective processes that are articulated in the making of artworks.

As a preface to the discussion of new configurations of revolt made available through contemporary practices, Kristeva turns to the etymology of the word 'revolt', and traces the way in which certain historical meanings articulate various strategies and processes of critique and transgression that have emerged in more recent aesthetic practices. Kristeva's later work has much to contribute to art practitioner-researchers, who are required to provide a rationale for the subjective and emergent approaches of artistic research. Indeed, her ideas can furnish the artist with the conceptual and theoretical frameworks for discussing the research process and outcomes, and articulating why and how artistic research reveals new knowledge.

Why 'revolt'?

Let us look at some of the meanings of 'revolt' Kristeva has mined from etymology in order to theorise new forms of aesthetic practice. She identifies a number of derivatives from the original term 'revolt', each of which hold connotations of transgression. In old French, the Latin verb '*volvere*' – 'to curve', 'to turn' and 'to return' – can mean 'to avert' (to revolt the face elsewhere) and also 'to envelop', 'to loaf about', 'to repair'. The Latin verb '*revolvere*', 'to consult' and to 're-read', adds an intellectual and interpretive dimension. In the fifteenth and sixteenth centuries, Italian meanings derived from '*volutes*' and '*voluta*' suggest circular movement, and by extension 'temporal return'. From these came the Italianism '*volte-face*' ('about face'), which suggests refusal or dissension. In the Middle Ages, the word 'revolution' was used to mark the end of a period of time that has evolved: 'It signifies a completion … Gradually the term comes to signify change, mutation' (Kristeva 2000: 2–3). The various historical meanings of the word 'revolt' provide a springboard for Kristeva's investigation of the emergence of new figures of revolt articulated in contemporary culture and art. Through this exercise in etymology, Kristeva illuminates how language operates as an externalisation

or emanation (in an altered form) of historical, embodied experience. Finally, Kristeva turns to Freud's conception of oedipal revolt and to the space of psychoanalytical practice in order to emphasise the importance of analysis and interpretation as a means of revealing the dynamics of prohibition and transgression:

I use the term 'revolt' here not in the sense of transgression but to describe the process of the analysand's retrieving his memory and beginning his work of anamnesis with the analyst, whom he refers to as a norm, if only because the analyst is the subject who is supposed to know, embodying the prohibition and its limits. (Kristeva 2000: 28)

For Freud, the word 'revolutionary' does not refer to moral or political revolt, but signifies the potential that psychoanalysis has to retrieve repressed or archaic material, to access a lost 'time'.

In her later work, Kristeva places a greater emphasis on the need for critical analysis as an aspect of practice, claiming that this is necessary because the art and culture of revolt produce unfamiliar or mutant meanings that are difficult for audiences to grasp. The capacity of art to effect social change and individual empowerment is dependent on interpretive practices that bring these meanings to light and illuminate their significance. She places the responsibility for this analysis and interpretation on the art critic. But what if the maker and the 'critic' become one and the same, as is in the case of artistic research? Can this shift in the status of artistic practice within the knowledge economy, and the significance this shift, be more clearly articulated through Kristeva's notion of the sense and non-sense of revolt? This chapter will explore these questions by revisiting aspects of Kristeva's thinking on experience-in-practice in the light of her more recent and extended elaboration of revolutionary practice. It will look at how Kristeva's ideas can provide artists with a framework for understanding creative arts research as the production of new knowledge.

If, as Kristeva argues, art and literature are among the few means of revolt and renewal, it seems appropriate to turn to her work on art as revolutionary practice in order to articulate a rationale and argument for claiming that practice as research can operate as a driver of change and innovation in contemporary culture. The first part of this task will involve tracing what Kristeva sees as three forms of revolt made possible through aesthetic experience. This will involve an extension of my earlier discussions of art as transgression that is predicated on individual experience. Following on from this discussion, I will explore how, by drawing on psychoanalysis, Kristeva's work constitutes both an implicit and explicit critique of science allowing us to conceive of artistic research as an alternative and performative production of knowledge. Finally in this chapter, I will apply and extend Kristeva's ideas on analysis and interpretation to an account of the artistic research completed by Australian photographer Wendy Beatty. In doing so, I hope to show that artistic practice, as a mode of enquiry, reveals the inextricable and necessary relationship between practice and theory, interpretation and making, art and life – and to show that it is this interrelationship that is crucial to creative and revolutionary practice. In the context of this discussion, it becomes clear that interpretation and analysis must fall to the practitioner-researcher, rather than to another person who has been external to the procedures of making – to trace the significant experiential, subjective and emergent processes involved in the production of the work. This self-reflexive analysis, as a second order of production or practice, is necessary if the generative and revolutionary impact of artistic research is to be understood within the broader social arena and the general field of research.

Three forms of revolt

Kristeva puts forward three figures of revolt, which when closely examined constitute a template for approaching artistic practice

as research. She refers to these in the following way: revolt as the transgression of prohibition; revolt as repetition, working through and working out; revolt as displacement, as combinative games (Kristeva 2000: 16). Let us examine each of these in more detail.

Revolt as the transgression of prohibition

You will recall that in *Revolution in Poetic Language*, Kristeva examined the notion of transgression and experience-in-practice, as involving a movement from a non-symbolised outside – triggered by material or objective contradictions. This confrontation and the material processes it engenders pulverises the unity of consciousness leading to the emergence of a new object and the return of knowing consciousness. Gilles Deleuze and Felix Guattari have described this process of production as a movement between deterritorialisation and reterritorialisation (Deleuze and Guattari 1987: 162). What distinguishes Kristeva's explanation from this is her focus on experience as something that connects with human affect, 'something unknown, surprise, pain, or delight and then comprehension of this impact' (Kristeva 2000: 11). The affective charge – the *jouissance* and laughter that attends the moment of rupture, incongruity and illumination in practice – is underscored by transgression and by something other than language. In *The Sense and Non-sense of Revolt*, Kristeva sees the need to extend her theorisation of revolt in response to the changing social and political landscape. Before examining the two additional figures of revolt that she introduces in this later work, it will be useful to deepen our understanding of the link between transgression and experience-in-practice and to locate these ideas within a framework of creative practice as a mode of enquiry.

Practice encloses and brings to knowledge the direct experience of reality. This occurs at the border on which the subject may 'shatter' or is put into crisis. This state, brought about by material contradiction or the pressure of drive and material process, is a

precondition for subjective renewal. From it, emerges the 'subject's' apprehension of a new heterogeneous object. The subject of this moment is not the fully constituted subject of the symbolic, but the subject in-process. Because practice dissolves the subject's self-presence, it puts the subject in a position to negate other objects and subjects within the frame of what constitutes the social. Practice introduces material contradictions into the subject as *process*; this is not necessarily antagonistic, but is brought about by the negativity of encountering the object prior to thought – as 'thing' presentation – rather than as an established category. In *Art Beyond Representation* (2004), Barbara Bolt describes this experience-in-practice as an aspect of 'working hot'. In material practices such as painting, there is an intensification of contradiction brought about by the unpredictable and/or accidental effects produced by the interactions of the materials and tools used in the making of the work. Often this requires speedy and spontaneous responses in which no time or space is left for rational thought. This does not mean, as Judith Butler has claimed in her notion of performativity (1993), that the subject is strictly speaking absent. The issue of the subject's absence in performativity turns on the relationship between Lacan's notion of an already constituted subject of language/ discourse and the heterogeneous subject of practice. In *Revolution in Poetic Language* Kristeva tells us that 'The subject never is, the subject is only the *signifying process* and he appears only as a signifying practice' (Kristeva 1984: 215). This reference to the absence of the subject in practice relates specifically to the subject as it is positioned or coalesced through the symbolic and the social rather than as a biological, living being.

However, Kristeva's notion of the 'speaking subject' posits heterogeneity, another layering or dimension of subjectivity as material process and contradiction capable of different forms of agency. The experience of practice puts the subject 'in process/on trial', a condition in which subjective processes are

predominantly determined by biological processes and drives, so that an alternative logic is at work. This is the logic of material process and of the unconscious, where there is 'no time' in the sense of linear temporality and where the binaries and contradictions of the symbolic and established discourses do not hold. The knowledge or reality brought about by direct experience is thus 'a *signifying apprehension* of a new heterogeneous object' (Kristeva 1984: 202). This articulates the subject as a passageway where there is a struggle between conflicting tendencies or drives whose stases or thetic moments are rooted in affective relations. This point is crucial to understanding why and how Kristeva places the subject and forms of subjective agency, rather than mechanistic or automatic processes, at the core of revolutionary practice.

The key term is 'affect' – positive and negative – that originates in pleasure and displeasure. We have seen in earlier discussions the way in which there is a constant struggle between the drive-ridden processes of the id, the pleasure principle and the ego, the reality principle. Without delving too deeply into Freud's account of the idiosyncratic workings of the pleasure principle, we can say that, pleasure can be understood as the removal or absence of displeasure. Negativity and rejection as aspects of the living organism's response to encounters with objects in the world give rise to sensation; accompanying raw sensation is affect experienced as fluctuating intensities. On the basis of pleasure or displeasure, these take on positive or negative valency and emerge as affects that attribute value(s) or 'colour' conscious meanings once they are grafted to the symbolic. Another term from psychoanalysis, 'cathexis', is pertinent here. Synonymous with 'investment' ('*investissement*'), cathexis is a drive that implicates subjective motivation in both libidinal and discursive economies. Charles Rycroft describes it as 'a quantity of energy attaching to any object or mental structure' (Rycroft 1972: 19). Hypercathexis involves an intensity of investment in one process or set of configurations in order to repress others. We can say

that cathexis is a moment of the coalescing of subjectivity according to the pleasures and displeasures of our encounters with objects – something between an emotional commitment and a vested interest in the relative rewards and satisfactions offered in processes of making and interpreting art as well as in other experiences. This will be illustrated presently, in an examination of photographer Wendy Beatty's account of her own experience-in-practice. It is also significant to understanding Kristeva's ideas about the way in which revolutionary practice is intensified when extant discourses no longer have value in terms of the lived experience of the subject. Indeed, it is this negating aspect of institutional discourses and the negative affects they invoke that impels creative practice as a search for, and renewal of, value.

Let me return for a moment to the idea of the subject or artist as a passageway. Martin Heidegger also uses this analogy or metaphor to describe the artist/subject in the process of making art. He suggests that the artist (and by extrapolation the subject) is largely inconsequential; as a passageway, it destroys itself in order for the work to emerge (Heidegger 1977: 166). There is a similar disavowal of the subject in Judith Butler's elaboration of performativity as a 'reiterative and citational' practice (Butler 1993). How can we explain this erasure of the subject and emanation of the work of art without falling into mysticism or elevating discourse to the transcendental? Kristeva suggests that psychoanalysis provides a way out of the impasse through its account of the relationship between biological processes and thought/language. In a sense, psychoanalysis gestures towards notions of a 'transcendental' that neither privileges the Cartesian subject nor social constructivist accounts of the subject – a transcendental that may be posited as an infinite dialectic involving *material process* as a two-way movement between biological processes and discourse. The subject as biological organism, capable of thought and language, is a 'filter' through which objects pass

as raw sensation and are then transubstantiated, if you like, into language. Kristeva observes:

Freud appeared to consider that language at once attests to the abyss between the two sides – excitability/thought – and possible passageways. Thrown over this abyss, however, is the bridge of language, for through language the two sides of excitability and thought will try to connect. You cannot say this excitability, but more exactly you say it without knowing it, unconsciously. (Kristeva 2000: 82)

In creative production, language becomes the space of an alternative or trans-linguistic representation that allows a *transfer* between instinctual conflict arising from the physiological on one hand, and conscious thought on the other. Situated between the body (energy, drive, excitability) and mind (representation), 'language allows thought to reach and stabilise energy' (Kristeva 2000: 35). The decentring of negativity-rejection in practice sets the subject's pulverisation against natural structures and social relations. However, heterogeneous contradiction sets up material processes in relation to an outside that is *not yet symbolised* because contradiction and conflict delay or defer rejection and the stases required to solidify meanings. This puts into play the dialectical process already discussed in earlier chapters, a process in which elements recombine through displacement and condensation to produce a new object. An investment of drive-rejection brings forth a new mental object whose determinations exist in material externality. Unlike the phobic object, this is not an apparition, but is constituted within the presence of consciousness as an embodied and situated apprehension of material reality. It is both the capture of something new about material reality not hitherto contained in established language, and the expansion of language itself.

The repressed element of practice is the already signifiable rejection, repressed because of the return to consciousness and the symbolic. Though consciousness represses this struggle (a

biological and social necessity), it is what consciousness will view as the moment of the appearance of the new object, an appearance that is first marked by laughter or *jouissance*: 'There is a strange problem in the way laughter works: the ego that laughs through the irruption of drive charge tearing open the symbolic is not the one that observes and knows' (Kristeva 1984: 224). The pleasure of the text is a kind of laughter or charge that must pass into discourse in order to affect the addressee or audience. This binding or investment of the drive prevents a drifting into nonsense, and in producing something new is already also a new prohibition. Laughter, then, is anterior to the subject of thought; it passes through and emerges from the subject as *process*.

What becomes clear in this explanation is the way in which the artist/subject can be understood as a passageway. This 'passageway' is not destroyed, but remains latent or masked by language; it prevails as infinite material process, inaccessible in normal discourse because the logic of the unconscious and of material process is repressed once there is a return to the symbolic. Hence we can appreciate Kristeva's observation that 'The demands of identity do not stem solely from a rationalist or Cartesian ideology' (Kristeva 2000: 18).

Performativity, science and a new materialism

What will be significant to the artist here is the idea that if we cannot consciously know an object without language, there follows a necessity for the production of new forms of language to mark or process the aesthetic encounter. This is contrary to notions of performativity in creative practice – either as a speech act – or as a citational practice emerging solely from an already constituted discourse. I'd like to pursue the way in which Kristeva's thinking illuminates how the creative act can be understood as 'performative', and to argue that it is her notion of performativity that provides firm grounds for claiming that creative practice is

a radical and alternative mode of enquiry capable of producing new knowledge.

The notion of performativity first gained currency through J.L. Austin's work, *How to Do Things With Words* (1962). Austin identifies a class of utterances he refers to as 'performative'. These go beyond describing or reporting actions and events, but actually perform the actions to which they refer. One example of such utterances used by Austin to illustrate this are the words 'I do' spoken in marriage ceremonies. Hence his claim that in certain contexts, making a statement of an action is equivalent to carrying it out. Alternatively, 'constative' utterances are statements that describe phenomena. Austin's ideas would suggest that there is no gap between language and the reality it represents. However, it does not capture the idea of inventive production that is implied in Kristeva's theory of creative textual practice. The user of language in Austin's account does not generate something new, but is a conscious ego who employs words that have socially agreed meanings. Butler recognises that this notion of performativity is related to performance as a deliberate act of a knowing subject. However, while she argues for a more generative 'performativity' – not as a singular act, but as the reiterative and citational practice from which transgressive or resistant gender identities emerge – she nevertheless privileges discourse and the symbolic law in her definition of performativity as a practice 'by which *discourse* produces the effects that it names' (Butler 1993: 2, emphasis mine). It is worth illustrating Butler's position with a lengthier quote in order to clarify her position and distinguish her understanding of materialisation from that of Kristeva:

In this sense what constitutes the fixity of the body, its contours, its movements, will be fully material, but materiality will be rethought as the effect of power, as power's most productive effect. And there will be no way to understand 'gender' as a cultural construct which is imposed on the surface of matter understood as the body or its given sex. Rather, once sex itself is understood in its normativity,

the materiality of the body will not be thinkable apart from the materialisation of that regulatory norm. (Butler 1993: 2)

Thus 'performativity' as practice and materialisation is, for Butler, an outcome of the symbolic law, an already constituted language and the social other – an outcome of secondary identification. This marks a distinction between Butler and Kristeva that can also be understood from my earlier discussions of the distinction between Lacan and Kristeva, and of Kristeva's theorisation of abjection and primary narcissism. Transgression in Butler's framework is always in opposition to and determined by established categories. Kristeva's thought, however, highlights material processes, abjection or separation/loss, as *pre-oedipal* processes. In her account, heterogeneity and negativity occur in relation to an as yet unsymbolised outside or other (Kristeva 1984: 203). This permits us to conceive of a more radically transgressive performativity; performativity as the bringing into view of the as yet unimaginable. It is only through the productive material renewal and alteration of language and an extension of discourse that this unimaginable may be accessed.

In putting forward the idea of creative practice as 'performative', Brad Haseman makes the following observation on creative practice as research: 'When research findings are presented as performative utterances, there is a double articulation with practice that brings into being what, for want of another word, it names' (Haseman 2007: 150). Although it suggests that practice as research indicates a radically new and different approach, Haseman's comment would seem to be drawing a correspondence between artistic research and science in presupposing or implying an unproblematic relationship between readymade language and the complex processes of production that occur in practice. Put simply, the scientific method involves close observation and the naming of what is observed. Haseman glosses over the issue of 'naming', an issue

which is at the heart of Kristeva's thought on creative production, which recognises that there is a gap between what language can describe or signify and reality. This is what underscores Kristeva's critique of science and opens up a different way of conceiving 'performativity'.

Another brief excursion into etymology is useful here. Among other definitions, the *Shorter Oxford Dictionary on Historical Principles* (Onions 1978) outlines the following derivations of 'perform/performativity': 'From Latin origins: To carry through to completion, an action, process, work etc'. In the sixteenth century: 'to complete by adding what is wanting' and 'to do, make', 'to do one's part', 'to discharge one's function', 'to go through'. The two meanings that are of interest here, 'to complete by adding what is wanting' and 'to do, make' imply a notion of productivity that involves actions and processes that are productive and yield something in *excess* of what existed prior to the action or process. Kristeva's view of creative practice aligns with this notion of performativity as production, and she provides a fine-grained analysis, via psychoanalysis, of the subjective processes at work in performativity. Through her thinking we can say that performativity in creative production or aesthetic experience involves an interaction between the subject as material process, as *being*, and the subject as *signifying process* resulting in a renewal and alteration of both the subject and language. This materialises or makes available to consciousness a new object of knowledge. In what way does this imply a critique of traditional accounts of the scientific mode of research?

Central to Kristeva's critique of science is the idea that it is founded on what she calls the methods of 'archivists, archaeologists and necrophiliacs'. Such methods were used to capture the truth about nature by classifying and encoding phenomena through a system of formal language that 'represses the process pervading the body and the subject' (Kristeva 1984: 13). Kristeva has shown that the notion of objective, empirical

observation as a possibility and truth as universal cannot hold if we are to take account of subjective processes. Moreover, the complexity and abstraction of social existence throws up much more than the scientific method can address or contain. Elsewhere (Barrett 2007), I have drawn on the work of philosopher of science Bruno Latour (1986) to highlight the way in which scientific truth is dependent on the mathematisation and modelling of ·scientific knowledge through the use of inscriptions and inscriptions of inscriptions. These are what Latour calls cascades of 'immutable mobiles' that are used in the formulation of scientific theories. Such theories are not built on the direct experience of practice to produce situated truth, as described by Kristeva, but resemble the circularity of sign giving way to sign. The logic of science is a logic that supposes a direct correspondence between naming and describing and the phenomena to which it refers. This logic presumes that the signifier designates the fullness of the referent and is flush with the referent. Kristeva exposes this logic in her account of proper names, which she describes via Bertrand Russell, as abbreviations of descriptions, that describe not particulars, but systems of particulars. Science not only abbreviates, but by collecting all the possible descriptions of phenomena into its formulae, symbolic representations, concepts and laws, it erases indeterminacy (Kristeva 1986b: 234). Aesthetic experience and art, on the other hand, operate through the particulars *and* indeterminacies of embodied experience-in-practice bringing into play an alternative logic that the logic of the *discourse* of science forecloses (Kristeva 1986b). My emphasis on 'discourse' in the previous sentence is deliberate, since many scientists have acknowledged that all 'real' discoveries in science have come about through processes that are ultimately aesthetic and subjective. This is made evident in philosopher and scientist Michael Polanyi's observation that 'Complete objectivity as usually attributed to the exact sciences is a delusion and in fact a false ideal' (Polanyi 1958: 18). In his

explanation of 'personal knowledge', Polanyi reveals the errors of positivism by showing that its account of scientific knowledge does not reflect the actual *practices* of science. This throws light on Kristeva's observation that the emergence of the true object in practice, should be distinguished from scientific *knowledge* about it, which will render its scientific truth only to lead in turn to another test-in-practice. The key to all of this is that scientific knowledge, which is predicated on description or naming, can only constitute a *partial* truth about reality.

Kristeva highlights the importance of testing the objects of knowledge produced in creative arts practice through her emphasis on the need for interpretation. The difference between experience-in-practice and other fleeting, or everyday, experiences is precisely this. In her explanation of the workings of negativity-rejection, the moment of practice implies testing to what degree the process of rejection corresponds to, or deviates from, natural or social processes it confronts. If drive-rejection does not invest in these, the violence of drive-rejection will reject all stasis until it reaches a point where it can symbolise the objective processes of transformation 'according to the constraints imposed on the movement of drives, in which case it produces a revolutionary "discourse"' (Kristeva 1984: 205). In the phase of 'working hot', the workings of rejection (material process) orchestrate what is laid down as an unconscious mark in a painting or a movement in dance. For this reason artists and audiences are often bewildered by work that is 'revolutionary'.

In Chapter 2 I discussed how the space of interpretation can be configured as the space of psychoanalysis, where there is a potential for a transfer of knowledge between the artist as analysand and the work itself as the "site" or figure of the analyst. A similar relationship is set up between viewer or interpreter of the artwork and the work of interpretation or testing proceeds as a creative practice in its own right. Through this process, the heterogeneous language of the artwork becomes the

site of inter-subjective exchange predominantly controlled by the structure of the artwork. Interpretation as and in creative practice produces a metalanguage by which the meanings of work can be accessed and made more readily available in relation to established discourses. In practice as research, the task is achieved through the exegesis or research paper that describes the processes of making and testing as well as the significance of the outcomes in terms of how they have expanded discourse in the field of practice and beyond it.

There remains one more point to be made in relation to the significance of Kristeva's work as a critique of science and as the positing of what may be understood as a 'new materialism'. This is linked to her notion of heterogeneous contradiction as materiality. Her focus on subjective processes as forms of agency must also be understood in relation to the 'agency' of materiality itself. Where traditional and Marxist accounts of materialism ultimately place consciousness at the centre of the apprehension of reality, Kristeva's work acknowledges the agency of 'brute' materiality. In creative production, there is no opposition between inside and outside – consciousness and materiality are mutually constitutive and enfolded. It is in this sense that we can begin to speak of a new materialism.

Telling tales: anamnesis as repetition and revolt

An understanding of the explanation that Kristeva gives us (via Freud[1]) of the initial transgression that constituted the moment of human entry into language is important in order to appreciate the significance of the relationship between narrative and psychic experience. Freud's *Totem and Taboo* can itself be viewed as a kind of anamnesis out of which he was able to build a psychoanalytical account of subjectivity and revolt. Kristeva's retelling of it in *The Sense and Non-sense of Revolt* not only constitutes part of her extended thesis on revolution and transgression, but is also a means of allowing the narrative, as *medium*, to become enfolded

in her theorisation. *Totem and Taboo* is also significant for an understanding of Freud's view that 'primitive' rites enacted through sacrifice, dance, incantation and other cathartic ritual experiences were precursors of art as we know it today. These ritual acts provide an insight into art (its production and reception) as the repetition of language itself. Art and ritual may be understood as the repetition or a return of language with difference, a process of sublimation through which lost memory is recuperated A brief account of Kristeva's retelling of Freud's narrative will help to illuminate this.

At an earlier time, when primitive men lived in hordes, the father dominated, and being all-powerful denied the sons' access to women. The initial transgression involved the murder of the father by the sons, who then ate the father. After this totemic meal, they replaced the image of the father with the totem symbol of power, the figure of the ancestor with which they identified. This identification, together with guilt and repentance, created a bond or social pact between the sons and also set up the prohibition against murder and incest. Kristeva concludes: 'The impulse of affection – which existed simultaneously with the impulse of hatred – was transformed into repentance and sealed as the social link which first appeared as a religious link' (Kristeva 2000: 12). Freud makes the point that rebellion leads to the forging of the social bond. As social beings, the brothers reabsorb the feminine in the sense of their love and affection for the father, but also renounce it as object of desire; the feminine can also be understood in terms of the passive desire of sons for the father. The fruit of rebellion is the appropriation of the father's qualities and the forging of the social bond as a result of guilt. The tale, then, is an allegory of the emergence of language as ritual and totem – as well as an explanation of the human desire for language. Why does Kristeva return to this allegorical origin of Freud's oedipal structure? She quotes Feud in explanation:

Satisfaction over the triumph led to the institution of the memorial festival of the totem meal in which the restrictions of deferred obedience no longer held. Thus it became a duty to repeat the crime of parricide again and again in the sacrifice of the totem animal, whenever as a result of the changing conditions of life, the cherished fruit of the crime – appropriation of the paternal attributes disappeared. (Freud quoted in Kristeva 2000: 13)

It becomes clear that a logical-psychological demand for the repetition of rebellion through ritual sacrifice and other forms of symbolisation emerges when the rewards of rebellion – pleasure in the social bonds – weakens. This occurs when 'I' feel excluded and/ or am no longer able to fix the locus of power in the shifting topologies of normalising and falsifiable discourses. Like other forms of art, the aesthetic dimension of narrative reproduces a 'sacrificial' situation – 'sacred sites' through which imaginary power is established and activated to constitute new forms of rebellion in contemporary secular society. Narrative as the repetition of language through verbal and visual storytelling becomes one of the means of accessing this imaginary power and lost memory. This is ever more crucial in the face of a contemporary culture of mass education, socialisation and information. While this imaginary power is not immediately evident in terms of its capacity for revolution, it bears the potential for revolt.

What we also see in Kristeva's extension of the notion of revolution is the need for a shift in critical focus from the processes of textual practice as an extension and renewal of language, to the social and political impact of such practices. This is pertinent to practitioner researchers seeking to articulate the way in which their modes of enquiry constitute forms of 'revolt' that make a difference.

Who can rebel?

Kristeva asks: 'If prohibition is obsolete, if values are losing steam, if power is illusive, if the spectacle unfolds relentlessly, if

pornography is accepted and diffused everywhere, who can rebel? Against whom, against what?' (Kristeva 2000: 28). It is in this context, she argues, that the prohibition/transgression dialectic must find new forms, both in practices of making and interpreting art, a point that was made explicit in my analysis of the work of Bill Henson in the previous chapter. Kristeva turns to Freud's view of the analytic space as a time of revolt, and draws correspondences between this space and the space of practice to emphasise the need for a critical and self-reflexive approach in creative practice. In the psychoanalytical space, the analysand is able to retrieve lost memory and lost time. What is important in anamnesis, or the patient's recounting of experience, is not the confrontation between prohibition and transgression, but movements and repetition – a working through and working out internal to free association in practice. Kristeva says that only in appearance is this process less conflictual than transgression.

In narrative, free verbal association puts thought processes on a level with perceptual processes, allowing thought to invest mnemic traces that fix the attention required for the retrieval of perceptual memories that have escaped thought. We can understand the idea of lost memory in several ways. Firstly, there is a lengthy period in the infant's development where the child is without language and is therefore unable to capture and articulate experience in words. Later in life, everyday encounters are littered with fleeting perceptions that are not captured in thought, but remain preconscious. Storytelling, as a type of utterance that affects both thought and perception, involves free association that can retrieve what has been lost to memory. In this process thought and perception become amalgamated in the artist's images, allowing memory to be put into words, bringing about the displacement of prohibition and possible renewal of psychic space. Kristeva draws on Nietzsche's idea that the universe recurs or repeats itself infinitely to explain the notion of retelling as an inherent aspect of human consciousness and memory. Retelling as

eternal return allows the passage of the abstract signifier from the unconscious into language; it creates a style that becomes a variant of revolt culture (Kristeva 2000: 28).

This process has been repeatedly demonstrated by the reflections of artists, writers and performers in artistic practice as a process of enquiry.[2] What is shown in each of the case studies of meta-reflection on their practices by artist themselves is the way in which practice arises from a need to resolve conflict or traumatic events, or the need to express experience by overcoming the limitations of available discourses. For writer Gaylene Perry, autobiography combines with fiction in her PhD novel Water's Edge (2001), later published by Picador under the title *Midnight Water: A memoir* (2004). The site of the retelling of the death of her father is a space of anamnesis, where imaginary elements merge with real-life events to produce insights that are both redemptive and entirely new. Perry acknowledges the imaginary power that the creative process engenders: 'In the act of creative writing, I gain personal empowerment that can effect change in my life' (Perry 2007: 35). In her PhD project, Silence: In Space of Words and Images (2002), Annette Iggulden's research leads to the forging of a new visual language that allows the artist to transgress social impositions of silence and to 'narrate' hitherto inchoate aspects of lived reality. Through the *process* of making, her project also revealed unknown aspects of the life of Medieval nuns from silenced orders. Dancer and choreographer Shaun McLeod demonstrates how dance as research can recuperate lost memory and make it visible. His research project '"Chamber": experiencing masculine identity through dance improvisation' (2002) involves transgressing accepted norms through movement in order to recuperate aspects of masculine experience that have been repressed and unanalysed in institutional and social discourses. These and other case studies illustrate the importance of analysis and interpretation as an integral aspect of articulating practice as 'revolt'. In each case,

subjective and particular concerns of the artists result in outcomes that have a wider social and cultural significance.

Displacement, combinatives, games

The third figure of revolt identified by Kristeva, that of displacement, combinatives and games is related to the notion of free association in verbal storytelling, but can be extended to other 'language' games or processes of meaning-making, such as those that occur in visual art, dance and performance. In such practices, the hiatus between drive or biological excitability may be understood as a gap between the sexual and the verbal.

Kristeva suggests combinatives and games – strategies that include the putting together of disparate or unlike objects in creative practice – engender condensations and displacements that involve a dynamic movement of meaning encompassed by, but not reduced to, language. She draws on Freud's earlier theory of the three registers of the psychic apparatus, neuronic excitation, thing presentation and word presentation to explain what she calls a 'layered' conception of language. Combinatives and games are strategies in creative practices that involve a movement between these registers with language acting as an intermediary. The process typifies postmodernist techniques of appropriation, the use of multiple styles that generate a plurality of meaning. In order for new meanings to emerge from such approaches, there must be some movement from nonsense to sense; that is to say the outcomes must make sense to an 'other', or audience. The transgressive dimension of these strategies lies in a tendency towards parody and refusal of fixed meaning. In such works, playfulness operates as a subtle questioning and critique of normative and normalising discourses.

In the context of creative practice as a process that moves between transgressive and established meanings we may conceive of the other as 'me' – the social self or subject, as opposed to the 'me' that is articulated by drive or excitability. An understanding

of this is essential if we are to appreciate the way in which material process operates as transgression and produces figures of revolt through creative practice. It is to this that I will now turn in my discussion of the photographic practice of photographer-researcher Wendy Beatty.

Feminist photographic techniques and multiple pleasures

The selection of images to be discussed come from an exhibition of black-and-white photographic works that formed part of a thesis/exegesis research project entitled 'Nude and Naked: Refiguring voyeuristic structures through feminist photographic techniques' (Beatty 2004). The project was completed in 2004, and the works were exhibited at the Four Cats Gallery in Melbourne in August of the same year in an exhibition entitled *Visual Pleasures*. Kristeva's thought provides both a backdrop and useful interpretive framework for discussing and understanding the process and outcomes of Beatty's artistic research project.

In this project, Beatty appropriates voyeuristic structures and traditional representations of the female nude in order to critique and extend the discourses surrounding such practices. Her aim is to put forward notions of difference and alterity operating in relation to conventional discourses of visual pleasure. Beatty does not resist the voyeuristic gaze, but her view is in keeping with Kristeva's idea of practice as a process of using language in order to make it signify differently. Her research as art practice aims to transfer the experience and discoveries of practice to the viewing audience by engendering an interactive engagement through visual disruptions. These are used to draw the viewer's attention away from representational realities to the viewer's own embodied experience and to encourage the viewer to relinquish customary ways of looking.

The artist's decision to use black-and-white photography and to include traditional darkroom methods is deliberate, in that she aims to experiment with the fluidity and unpredictability of

the material processes of production. By acknowledging the inherent autonomy and agency of her materials, Beatty is able to create a site of interaction that demands spontaneous responses, a degree of free play between controlled craftsmanship and prior expectations, and her own conscious and unconscious processes. Her practice involves exploiting the technical and aesthetic potential of photography to show how conventional discourses and photography, as a ubiquitous genre of image-making, has come to be encoded in popular culture, through structures that limit the gaze and therefore the possibilities of viewing pleasure. Her objective is to demonstrate how photographic practices can operate as transgression by deconstructing conventions of viewing

6. Wendy Beatty, *Untitled #2*, (2004),
black and white photograph.

and extending notions of visual pleasure beyond customary patriarchal frameworks.

Photographic codes related to camerawork – shot, focus, composition, editing, lighting, colour and so on – have been internalised in ways that inform and construct viewing pleasures. The works Beatty produced from this enquiry constitute a challenge to these codes. As an alternative 'narrative' of viewing pleasure, the work refuses fixity and conventional male/female dichotomies. It is also a recuperation of the lived experience of the female body that traditional aesthetics and representations of the nude have tended to repress. In this sense, Beatty's practice may be understood as 'transgression' and as an attempt to expand extant discourse and knowledge surrounding photographic practices.

Beatty's practice involves relinquishing the certainty of the gaze in favour of ambiguity, and in doing so evoking the viewer's

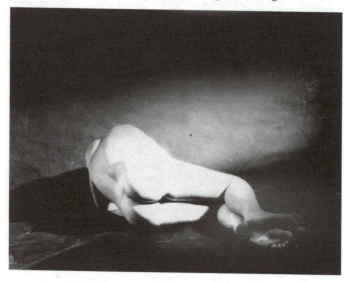

7. Wendy Beatty, *Untitled #3*, (2004), black and white photograph.

desire through embodied engagement with the materiality of the images rather than with encoded categories of what constitutes beauty (Beatty 2004: 12). By manipulating the gaze and drawing attention to the phallic regime, her work exposes its normalising constructions. The artist asserts that art and aesthetic experience can reveal how the rules and binaries of (visual) language contradict their own logic, and applies Kristeva's semanalysis as a tool for analysing and mapping the points where her images

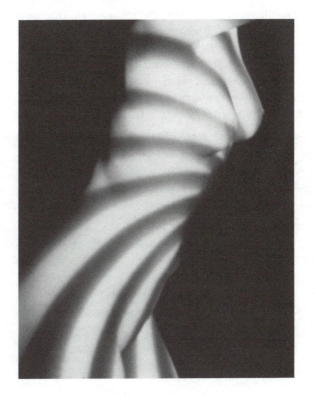

8. Wendy Beatty, *Untitled #12*, (2004), black and white photograph.

transgress the codes of nude portraiture. A basic premise of her research is the idea that as we acquire language through practice we learn to give voice to experience as it is lived and felt. Drawing on feminist theories of the body, her work, like that of other women artists, is a critique of art practices that perpetuate a visibly masculine aesthetic. At the same time, it is an attempt to realise a feminist aesthetic that articulates the feminine as it is experienced (Beatty 2004: 89).

Beatty focuses on bodies in real life, and attempts to translate the experience of the bodies into the artwork. This involves a conscious breaking of taboos surrounding female libido through a direct reference to female genitalia, not according to the constraints of established norms and discourses, but through self-representation and reference to a libido of self-pleasuring and self-relation. The body of works produced are self-portraits and portraits of friends (rather than professional models), in

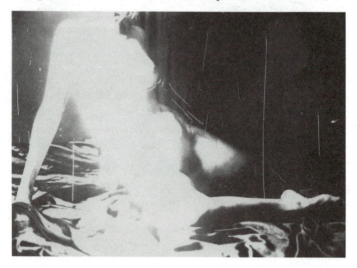

9. Wendy Beatty, *Untitled #7*, (2004), black and white photograph.

everyday settings. These are later manipulated in the studio and subjected to digital printing and reprinting until the desired effect has been achieved. The process can be understood through Kristeva's account of revolt as a working through and working out, and also in terms of the displacement made possible though combinatives that produce new topologies and spatial configurations through image-making.

In the work *Untitled #2* (Figure 6) the reclining pose, traditionally an iconic sign or signifier related to phallic pleasure, is replaced by a standing figure. However, the modal effects of light and shadow heighten the tactile qualities of the skin's surface to draw attention away from erotic elements and to emphasise the muscularity and 'lived' corporeal aspects of the body. Though centrally positioned, the female figure is both awkward and defiant in its pose. Sexual attributes, often emphasised in traditional nude portraits, are also obscured through the artist's technique of toning and bleaching of the image. The work's construction transfers an embodied and experiential dimension to the viewing process. It triggers positive affect, identification and desire related to an empathetic, rather than an objectifying, gaze. The movement between representational and abstract elements and between light and dark instantiates heterogeneous contradiction and creates ambiguity, so that the figure refuses objectification and eroticisation. Consequently, normal expectations and customary ways of looking are disrupted. Pleasure is redirected and becomes multiple and diffuse rather than fixed and conventionally sexualised.

Similar effects are achieved in *Untitled #3* (Figure 7), where the figure is presented as ambiguous in gender. Compositionally, the work refuses any predetermined viewing position, and this produces a multiplicity and variability in the construction of the gaze and possibilities for viewing pleasure. Obscuring the head of the figure suggests that there is something beyond representation; and at same time gives rise to the abject. The

added ambiguity triggers imaginary processes and the drive to create new *gestalts*. The artist's use of abjection resists the naturalisation of what is abjected; instead, abjection becomes a sign of difference and threat that refuses objectification; this confers feminine power, rather than the passivity that is characteristic in traditional representations of the nude.

In most of the manually manipulated images, surface markings created through darkroom processes are retained. Contradictions produced in this way interrupt the gaze so that traditional distancing effects found in conventional nude paintings are avoided. In Kristevan terms, the viewer of these images becomes a subject that is put into crisis through a confrontation with material contradiction. This results in a production of meaning that operates beyond representational elements and conventional meanings. This effect, also produced by the deliberate abjecting of the female form, is enhanced through digital means, as is the case in the work *Untitled #12*. (Figure 8). In this work, the aesthetic effects achieved by the manipulation of formal elements evoke pleasure despite the deformations produced through digital cropping, cutting and reassembling of body parts that would otherwise be conveyed in sexualised poses.

The work *Untitled #7* (Figure 9), exemplifies the technique of combining and manipulating compositional and modal elements that construct the objectifying gaze. The effects of parody are further realised by the artist's appropriation and reworking of conventional renderings of the reclining nude. The manipulation of representational value through scratching, bleaching and lighting draws the viewer's attention away from the representational reality of the figure, and also blurs distinctions between 'reality' and the constructed nature of representational language. These effects are enhanced and extended by a reprocessing and reprinting of the image to obscure or overlay parts of a body that was originally photographed in a different pose.

The structure of Beatty's images encourages the viewer to contemplate what falls outside the representational regime. It also questions the notion that the indexical quality of the photographic image corresponds to perceptual experience. These works articulate the heterogeneity of visual language and the instability of meaning. Beatty's practice reflects Kristeva's view that language, when it is put into process through creative production, holds the potential for transgression, revolt and the production of the new.

Beatty observes that the effects produced in this body of work were only made possible through experimentation and manipulation of photographic processes in the studio (Beatty 2004: 111). Moving between the known and the anticipated (though not predetermined) possibilities of darkroom and other photographic processes involves a critical vigilance. However, the artist asserts that it is the *jouissance* of the transgressive moment, as it arises in the making of a work that ultimately determines the final outcome. The non-idealised figures in her images appear to open up an erotic space that falls outside the containment of conventional (visual) language, so that the process, as it is *experienced in practice*, informs decisions that will determine what the work will look like: 'Moments of breakthrough arrive when the works begin to reveal a positive interest and appeal in the way the female body and pleasure are situated outside traditional restraints and voyeuristic discourses' (Beatty 2004: 8).

Beatty experiences a sense of power, shock and pleasure through her practice, and attempts to transfer this experience to the viewing audience. For her, pleasure and desire is derived from the way in which experience-in-practice leads to the production of new and transgressive configurations. These forms challenge and question the phallocentric gaze and institutional structures that enframe a particular kind of feminine ideal by returning to lived experience. In this sense Beatty's work, and her account of it in

the accompanying exegesis, highlights the importance of understanding creative production as objective enquiry *and* subjective, material process. This double articulation constitutes a performative production that in Kristevan terms may be understood as 'revolutionary'.

Conclusion

If at first bewildering and seemingly impenetrable, the writings of Julia Kristeva will reward art-makers, critics and audiences with the keys to understanding the desire and passion that drives human creativity. Her work reveals that aesthetic experience engendered in both making and encountering art is a transformative process vital to the renewal of our imaginary capacities. It is hoped that this reframing of Kristeva has gone some distance towards opening up her work in ways that will lead to further engagement and the *jouissance* that reading her is sure to bring.

Notes

Chapter 4

1 See Vladimir Propp (1968) *Morphology of the Folktale*, trans. Laurence Scott, Austin, TX: University of Texas Press. Propp's account of narrative structure illuminates the differential structuring of gender in folk tales.

Chapter 5

1 Kristeva draws on Freud's account of transgression in *Totem and Taboo*, which she suggests is not as subjective or implausible as some might like to think. Sigmund Freud (1950) *Totem and Taboo: Some points of agreement between the mental lives of savages and neurotics*, trans. James Strachey, New York: Norton.
2 See reflections on their own practices as research by Gaylene Perry, Annette Iggulden and Shaun Mcleod, in Estelle Barrett and Barbara Bolt (eds) (2007) *Practice as Research: Approaches to creative arts enquiry*, London: I.B.Tauris.

References

Austin, J.L. (1962) *How to Do Things With Words*, Urmson, J.O. and Marina Sbisà (eds), Oxford: Clarendon Press.

Banazis, Linda (1993) interview, Perth, Western Australia, 7 August.

Barrett, Estelle (2007) 'Foucault's "What is an author": towards a critical discourse of practice as research', in Estelle Barrett and Barbara Bolt (eds) *Practice as Research: Approaches to creative arts enquiry*, London and New York, I.B.Tauris, pp. 136–46.

Barrett, Estelle and Bolt, Barbara (eds) (2007) *Practice as Research: Approaches to creative arts enquiry*, London and New York, I.B.Tauris.

Barthes, Roland (1966) *Critique et Vérité*, Paris: Seuil.

—— (1972) *Critical Essays*, trans. Richard Howard, Evanston: North Western University Press.

—— (1975) *The Pleasure of the Text*, trans. Richard Miller, New York: Hall and Wang.

Beardsworth, Sara (2004) *Julia Kristeva: Psychoanalysis and modernity*, Albany, NY: State University of New York Press.

Beatty, Wendy (2004) 'Nude and Naked: Refiguring voyeuristic structures through feminist photographic techniques' (unpublished MA thesis), Melbourne: Deakin University.

Bennett, Jill (2005) *Empathic Vision*, Stanford, CA: Stanford University Press.

Bolt, Barbara (2004) *Art Beyond Representation: The performative power of the image*, London and New York: I.B.Tauris.

Burgin, Victor (1990) 'Geometry and abjection', in John Fletcher and Andrew Benjamin (eds) *Abjection, Melancholia and Love: The work of Julia Kristeva*, London and New York: Routledge, pp. 104–23.

Butler, Judith (1993) *Bodies That Matter: On the discursive limits of 'sex'*, New York and London: Routledge.

Chase, Cynthia (1990) 'Primary narcissism and the giving of figure: Kristeva with Hertz and de Man', in John Fletcher and Andrew Benjamin (eds) *Abjection, Melancholia and Love: The work of Julia Kristeva*, London and New York: Routledge, pp. 124–36.

Creed, Barbara (1986) 'Horror and the monstrous feminine: an imaginary abjection', *Screen*, vol. 27, no.1 (January–February), pp. 41–70.

Crombie, Isobel (1995) *Bill Henson: Untitled*, Exhibition Catalogue, Australian Pavilion, Venice Biennale, Melbourne: Australian Exhibitions Touring Agency.

—— (1996) *Untitled: The photographs of Bill Henson*, exhibition room brochure, Melbourne: Australian Exhibitions Touring Agency.

Damasio, Antonio R. (1999) *The Feeling of What Happens: Body and emotion in the making of consciousness*, New York: Harcourt, Brace.

Deleuze, Gilles and Guattari, Felix (1987) *A Thousand Plateaus: Capitalism and schizophrenia*, trans. B. Masumi, Minneapolis, MN: University of Minnesota Press.

Florman, Lisa (2003) 'The difference experience makes in "The Philosophical Brothel"', *Art Bulletin*, vol. 85, no .4, pp. 769–83.

Foster, Hal (2008) 'Trauma culture', http://www.artnet.com/magazine_pre2000/features/foster/foster7-26-96.asp (accessed 19 August 2008).

Foucault, Michel (1981) 'The subject and power', *Critical Enquiry*, vol. 8, no.4, pp. 777–89.

Freud, Sigmund (1923/1984) 'The ego and the id', *Penguin Freud Library on Metapsychology*, vol. 11: *The Theory of Psychoanalysis*, trans. J. Strachey, Harmondsworth: Penguin.

—— (1927/1981), 'Fetishism', in *On Sexuality*, vol. 7, Hardmondsworth: Penguin.

—— (1950) *Totem and Taboo: Some points of agreement between the mental lives of savages and neurotics*, trans. James Strachey, New York: Norton.

—— (1953/1974) *The Standard Edition of the Complete Psychological Works*, vol. 14, James Strachey (ed.), London: Hogarth.

Haraway, Donna (1991) *Simians, Cyborgs and Women*, New York: Free Association Books.

Haseman, Brad (2007) 'Rupture and recognition: identifying the performative research paradigm', in Estelle Barrett and Barbara Bolt (eds) *Practice as Research: Approaches to creative arts enquiry*, London and New York, I.B.Tauris, pp. 147–57.

Hegel, G.W.F. (1929/1966) *Science of Logic*, 2 vols, trans. W.H. Johnson and L.G. Struthers, London: Allen and Unwin.

Heidegger, Martin (1977) *Basic Writings*, D. Farrell Krell (ed.), San Francisco: Harper and Row.

Hughes, Robert (1980) *The Shock of the New: Art and the century of change*, London: BBC.

Iggulden, Annette (2002) 'Women's silence: in the space of words and images', (unpublished PhD thesis), Melbourne: Deakin University.

—— (2007) '"Silent" speech', in Estelle Barrett and Barbara Bolt (eds) *Practice as Research: Approaches to creative arts enquiry*, London and New York, I.B.Tauris, pp. 65–79.

Kristeva, Julia (1980) *Desire in Language: A semiotic approach to literature and art*, Leon S. Roudiez (ed.), trans. Alice Jardine and Leon S. Roudiez, New York: Columbia University Press.

—— (1982) *Powers of Horror: An essay on abjection*, trans. Leon S. Roudiez, New York: Columbia University Press.

—— (1984) *Revolution in Poetic Language*, trans. Margaret Waller, introd. Leon S. Roudiez, New York: Columbia University Press.

—— (1986a) 'The system and the speaking subject', in Toril Moi (ed.) *The Kristeva Reader*, Oxford: Basil Blackwell, pp. 24–33.

—— (1986b) 'The true-real', in Toril Moi (ed.) *The Kristeva Reader*, Oxford: Basil Blackwell, pp. 214–35.

—— (1987) *Tales of Love*, trans. Leon S. Roudiez, New York: Columbia University Press.

—— (1989) *Black Sun: Depression and melancholia*, trans. Leon S. Roudiez, New York: Columbia University Press.

—— (1991) *Strangers to Ourselves*, trans. Leon S. Roudiez, New York, Chichester, West Sussex: Columbia University Press.

—— (1995) *New Maladies of the Soul*, trans. Ross Guberman, New York: Columbia University Press.

—— (2000) *The Sense and Non-sense of Revolt*, trans. Jeanine Herman, New York: Columbia University Press.

Lacan, Jacques (1977) *Écrits: A selection*, trans. Alan Sheridan, London: Tavistock Publications.

Latour, Bruno (1986) 'Visualization and cognition: thinking with eyes and hands', *Knowledge and Society: Studies in the sociology of culture past and present*, vol. 6, pp. 1–40.

Lechte, John (1990a) 'Art, love and melancholy', in John Fletcher and Andrew Benjamin (eds), *Abjection, Melancholia and Love: The work of Julia Kristeva*, London and New York: Routledge, pp. 342–50.

Lechte, John (1990b) 'Kristeva and Holbein, artist of melancholy', *British Journal of Aesthetics*, vol. 30, no .4, (October), pp. 342–50.

Levine, Steven Z. (2008) *Lacan Reframed*, London and New York: I.B.Tauris.

McAfee, Noëlle (2004) *Julia Kristeva*, New York: Routledge.

McEvilley, Thomas (1986) 'Introduction', in Brian O'Doherty, *Inside the White Cube*, Santa Monica, CA: Lapis Press.

McLeod, Shaun (2002) '"Chamber": experiencing masculine identity through dance improvisation' (unpublished MA thesis), Melbourne: Deakin University.

—— (2007) '"Chamber": experiencing masculine identity through dance improvisation', in Estelle Barrett and Barbara Bolt (eds) *Practice as Research: Approaches to creative arts enquiry*, London and New York, I.B.Tauris, pp. 81–97.

Metzinger, Jean (1992) 'Note on Painting', in Charles Harrison and Paul Wood (eds) *Art in Theory 1900–1990: An anthology of changing ideas*, Oxford and Cambridge, MA: Blackwell, pp. 177–8.

Miller, Alice (1990) *Banished Knowledge*, London: Virago.

Mulvey, Laura (1981) 'Visual pleasure and narrative cinema', in Tony Bennett et al. (eds) *Popular Television and Film*, London: BFI, pp. 206–15.

O'Doherty, Brian (1986) *Inside the White Cube*, introd. Thomas McEvilley, Santa Monica, CA: Lapis Press.

O'Toole, Michael (1994) *The Language of Displayed Art*, London: Leicester University Press.

Onions, C.T. (ed.) (1978) *The Shorter Oxford Dictionary on Historical Principles*, vol. 11, 3rd edition, Oxford: Clarendon Press.

Perry, Gaylene (2001) '"Water's Edge" and the "Water's Edge" Writing' (unpublished PhD thesis), Melbourne: Deakin University.

—— (2004) *Midnight Water: A memoir*, Sydney: Picador.

—— (2007) 'History documents, art reveals: creative writing as research', in Estelle Barrett and Barbara Bolt (eds) *Practice as research: Approaches to creative arts enquiry*, London and New York, I.B.Tauris, pp. 35–45.

Picasso, Pablo (1968) 'Cubism', in B. Herschell (ed.) *Theories of Modern Art*, Berkeley, CA: University of California Press, pp. 271–8.

Polanyi, M. (1958) *Personal Knowledge*, London: Routledge and Kegan Paul.

Roudiez, Leon S. (1984) 'Introduction', in Julia Kristeva, *Revolution in Poetic Language*, trans. Margaret Waller, introd. Leon S. Roudiez, New York: Columbia University Press, pp. 1–10.

Rowley, Alison (1993) 'Painting – a male act?', *Arm*, 'Feminisms' issue, Western Australia: Perth Institute of Contemporary Art.

Rubin, William (1994), 'The genesis of *Les Demoiselles d'Avignon*', special issue of *Studies in Modern Art*, vol. 3, New York: Museum of Modern Art, pp. 13–144.

Rycroft, Charles (1972) *A Critical Dictionary of Psychoanalysis*, 2nd edition, London: Penguin.

Scheer, Edward (1998) 'Deadly visions: at home in the abyss', *Real Time* (Sydney), no. 26 (September), p. 29.

Sjöholm, Cecilia (2005) *Kristeva and the Political*, London and New York: Routledge.

Sontag, Susan (1977) *On Photography*, Harmondsworth: Penguin.

Steinberg, Leo (1988) 'The philosophical brothel', *October*, vol. 44 (Spring), pp. 7–74.

Thompson, Nato (2004) 'Strategic visuality: a project by four artists/researchers', *Journal of Art*, vol. 63, no. 1 (Spring) pp. 38–40.

Glossary

aesthetics – Traditionally concerned with principles of the beautiful in art, and doctrines of what constitutes taste. Kristevan aesthetics emphasises embodied experience (perception, sensory experience, affect and emotion) as opposed to conceptual and rational thought.

affects – Internal 'representations' or archaic energy signals initially occurring as undifferentiated 'intensities'. The investment of drive energy (cathexis) attributes negative or positive value, transforming affects into feelings, emotions and conscious thought.

anamnesis – In medicine, the patient's retelling of the history of an illness; in psychoanalysis it refers to the patient's recounting of experience to the analyst in order to effect a cure or resolution to psychological conflicts.

atavism – The existence of a trait or characteristic belonging to earlier generations that reappears; indicates reversion to an earlier type.

castration – In Freudian theory, the emergence and development of the ego turns on recognition of sexual difference – the possession or lack of the penis. Women are thus viewed as castrated. In Lacanian theory, the visible primacy of the male organ constitutes the phallus as the primary signifier, and woman as 'lack' or symbolically 'castrated'.

cathexis – Investment of drive energy into an object, representation or mental structure; a moment of the coalescing of subjectivity according to the pleasures and displeasures of our encounters with objects.

chora – A space or domain of energy charges and psychical marks that develops through the infant's relation to the mother prior to its entry into language; it is what produces semiotic meanings or meanings that are related to embodied experience and affect; can also refer to the dynamism of the body constantly seeking to maximise the living organism's capacities through interactions with what lies outside the body.

dénégation – Implies both a negation and disavowal of the mother ('I have lost her'), but also an implicit affirmation ('I can reconnect with her through language').

desire – According to Lacan, desire is constituted in the field of symbolic relations as a drive that is constantly in search of what was lost on entry into language. Because language is only a partial substitute for the object, desire emerges as lack. Kristeva theorises desire not only in relation to the absence the signifier implies, but also in relation to the semiotic or what the symbolic does not make explicit; in her schema, desire emerges as productivity.

dialectics – Hegelian dialectics involves a process by which the contradiction between thesis and antithesis is resolved through a synthesis of the two; Marxist dialectics suggests that the struggle between the two elements of a contradiction results in the elimination of the weaker element. Kristeva's more radical view of dialectics is informed by catastrophe theory – the idea that small changes and contradictions in parts of a non-linear system can cause instabilities that lead to sudden changes in the whole system. When elements in the system lose equilibrium or are shattered, one element does not replace another, but shattered elements re-form to bring about a completely *new* system.

drive – Instinctual processes and energies related to pleasure and absence of pleasure and involved in maintaining homeostatic processes or the internal stability of the organism. Death-drive can be directed outwardly as a destructive discharge of energy, or inwardly as a wish to remove

contradictions by disintegrating the self and returning to an inorganic state or 'pure' homeostasis. Life-drive or erotic-drive is directed towards, and invested in, objects of pleasure and satisfaction.

ego – The part of the psychic apparatus that is organised in relation to rational thought. It is responsible for reconciling the demands of the id (the pleasure principle) with social demands (the reality principle).

ego ideal – The subject's perception of how he/she wishes to be; develops through secondary narcissism, idealisation and identification with ideal others.

expenditure – Refers to the *jouissance* or pleasure that accompanies material contradictions – negativity and rejection working together to generate the semiotic functioning of language.

genotext – Aspect of the literary text or artwork that indicates the semiotic disposition of language, a capacity for play and pleasure, and that refuses the constraints of the symbolic.

hallucination – Also 'phantasm'; an internal mental image that does not relate to external objects or reality.

heterogeneous – Composed of different or unlike elements or parts. Language is heterogeneous because it is made up of the symbolic, rule-bound and signifying elements and the semiotic, related to embodied experience and biological/material processes.

id – The site of the drives and the organism's instinctual processes related to nourishment, sexual attraction and aggressive self-protection (the pleasure principle).

ideal ego – The virtual image of self in the mirror that is mistaken for reality; also relates to primary narcissism and identification with

images of the mother and immediate others in the child's early life prior to the acquisition of language, when self is felt to be continuous with the mother.

identification – The assimilation of the feelings of another into the self; a feeling of being one with another. Primary identification is the feeling of oneness with the mother before separation and the emergence of objects. Identification is also a process by which the subject extends his/her identity into another person, borrows identity from another person or confuses his/her identity with someone else.

imaginary (the) – Psychic structure that emerges in the mirror stage. Lacan suggests that this occurs between six and eighteen months, when the infant's sense of self develops in relation to *images* rather than language; the child misrecognises itself as a totality or full body in the 'mirror'. The 'mirror' also relates to images of the mother and immediate others in the child's early life prior to the acquisition of language. Kristeva says that the imaginary occurs much earlier, and is related to the chora, where the infant's energies and psychic space are constituted in relation to the mother as primary care-giver.

introjection – The process of internalisation and incorporation that allows external objects to be transformed into mental or internal representations.

jouissance – Depending on the context, refers to pleasure, ecstasy, enjoyment and satisfaction. *Jouissance* can be any, or a combination of all, of the following: sexual, spiritual, physical and intellectual pleasure.

narcissism – Primary narcissism is the love of the self, which precedes love of others; this is the love experienced before separation, when the child sees itself as continuous with others and libido is directed inward as auto-eroticism. Secondary narcissism is love of the self, based on introjections and identification with objects and with ego ideals.

negation – The process of repression that allows an object to emerge through language; the negation of the mother is necessary in order to recuperate her in language.

negativity – The motility and dynamism of drive energies, biological responsiveness to objects (including language and ideas).

performativity – In creative practice, materialisation or the bringing into view of the as yet unimaginable through material processes that remake and renew the subject and language.

pervious – Refers to something that is permeable, indicates a passage or flow across borders; it can refer to the relationship between mind and body, language and biological processes, the individual and society.

phallic mother – The mother as the source of all satisfaction, and as she is experienced prior to the child's entry into language.

phenotext – The signifying dimension of language related to the symbolic and its grammatical rules.

rejection – A movement that interrupts negativity and moves between the drives and consciousness. Together, rejection and negativity constitute a rhythmic responsiveness to language and other objects in the world.

semanalysis – Kristeva's interpretive method; it goes beyond linguistics-based semiotics and involves looking for meanings that exceed or fall outside the rules of a signifying system.

semiotic (*le sémiotique*) – The dimension of language related to embodied experience, material and biological process, affect and emotion; it refers to the way in which instinctual drive affects language by disrupting and multiplying meaning.

signifiance – Meanings produced in relation to fluid archaic processes of the infant's early relationship to the mother's body; the unceasing operation of drives in and through language indicating the heterogeneous disposition of language that allows a text to signify what everyday communicative language cannot articulate.

subject/subjectivity – The thinking, speaking and acting self; Kristeva posits the subject and subjectivity as a self that is heterogeneous. Her 'speaking subject' is split between conscious and unconscious motivations and is constituted through social *and* biological processes.

superego – That part of the ego involved in self-observation and self-criticism related to parental values and social prohibitions. The superego differs from what we call 'conscience' because it is also influenced by the unconscious, and by impulses that arise in the child prior to its entry into language.

symbolic – Language as a sign system that operates through rules and codes, to communicate shared or established meanings.

tendential – Referring to a notion that can be posited conceptually or theoretically, but does not refer to actuality. For example, the separation of the semiotic from the symbolic is *tendential*, because there can be no symbolic without the semiotic and vice versa.

thing presentation – The presentation of the object to consciousness via raw perception and the pressure of unconscious drive (material or biological process), as opposed to the presentation of the object as a verbal or linguistic category.

transcendence – The dictum 'I think, therefore I am' posits a transcendental ego of rational thought, and elevates consciousness as the source of knowledge. Theories of the unconscious challenge this notion of a transcendental ego. Kristeva's work posits a materialist

form of transcendence or immanence – knowledge emerging from within the interrelationship of the subject, material and biological processes and language.

transference – The inter-subjective exchange of affect and emotion between patient and analyst in the retelling of experience.

trauma – A distressing or upsetting experience that is imposed on a subject and can have lasting consequences, irrespective of whether it can be recalled.

Index